Graphic Design
TRICKS
& TECHNIQUES

Graphic Design

TRICKS

& TECHNIQUES

Molly Joss & Lycette Nelson

NORTH LIGHT BOOKS

Cincinnati, Ohio

Graphic Design Tricks & Techniques. Copyright © 1997 by Molly W. Joss and Lycette Nelson. Printed and bound in Singapore. All rights reserved. No part of this book may be reproduced in any form or by any electronic or mechanical means including information storage and retrieval systems without permission in writing from the publisher, except by a reviewer, who may quote brief passages in a review. Published by North Light Books, an imprint of F&W Publications, Inc., 1507 Dana Avenue, Cincinnati, Ohio 45207. (800) 289-0963. First edition.

Other fine North Light Books are available from your local bookstore, art supply store or direct from the publisher.

01 00 99 98 97 5 4 3 2 1

Library of Congress Cataloging-in-Publication Data

Joss, Molly W.,
 Graphic design tricks & techniques / Molly W. Joss and Lycette Nelson.
 p. cm.
 Includes indexes.
 ISBN 0-89134-774-7 (alk. paper)
 1. Layout (Printing) I. Nelson, Lycette. II. Title.
 Z246.J68 1997
 686.2'252–dc21 97-10546
 CIP

Edited by Lycette Nelson with Kate York and Lynn Haller
Production edited by Jennifer Lepore
Interior and cover designed by Chad Planner

The permissions on page 134-135 constitute an extension of this copyright page.

North Light Books are available for sales promotions, premiums and fund-raising use. Special editions or book excerpts can also be created to specification. For details, contact the Special Sales Manager, F&W Publications, 1507 Dana Avenue, Cincinnati, Ohio 45207.

ABOUT THE AUTHORS

Molly W. Joss is an independent writer and consultant based in Gilbertsville, Pennsylvania. She is a regular contributor to *Electronic Publishing*, *Print on Demand Business*, the *NADTP Journal*, *CD-ROM Professional*, and *The Seybold Reports*. She is a contributing editor to *Pre-* and *Computer User*.

Joss' work as a consultant includes helping publishers create electronic publishing products, improve their marketing efforts and select desktop publishing hardware and software.

Lycette Nelson is a Cincinnati-based freelance writer and editor specializing in graphic design, multimedia and technology trends. She is the former managing editor of *HOW* magazine and the former associate editor of *CADalyst* magazine. She has written numerous articles on technology topics, type design, interactive design and the business of graphic design.

ACKNOWLEDGMENTS

The authors would like to thank their editors at North Light Books, in particular, Lynn Haller, editor, and Kate York, associate editor, Graphic Design Books, for all their guidance and support. They also extend their thanks to all those who contributed to this book or gave permission for their work to be used. *Graphic Design Tricks & Techniques* represents the contributions of many individuals and design staffs who took the time to share their experience and their work with others.

table of

contents

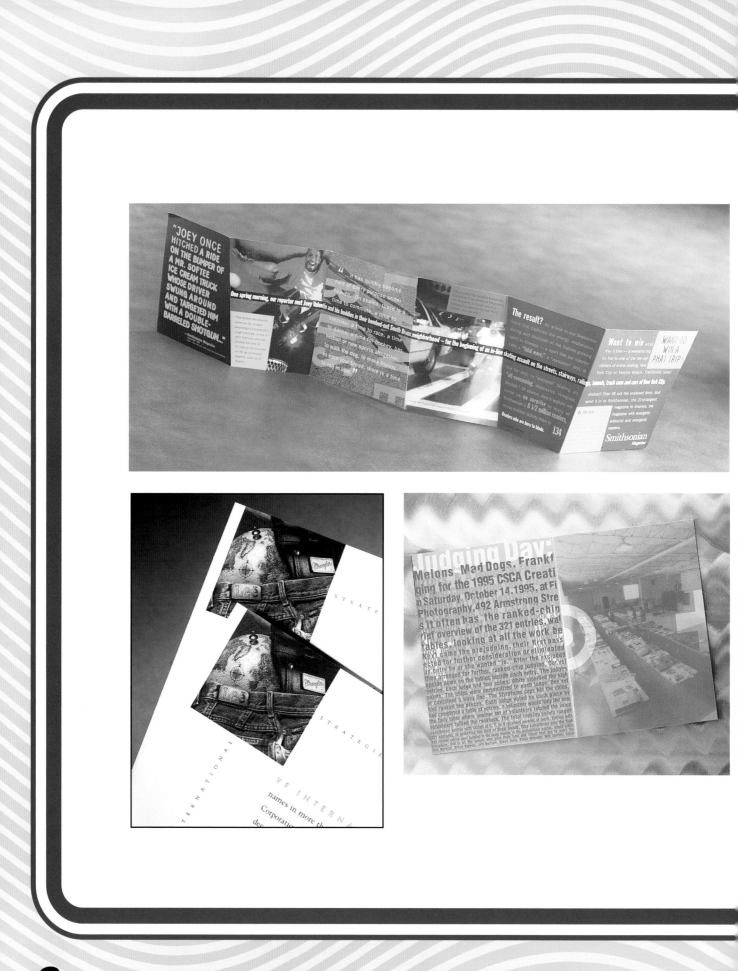

INTRODUCTION

Graphic Design Tricks & Techniques is a compendium of close to three hundred tips from designers, photographers, typographers, prepress and printing experts, and other graphics professionals from around the United States and Canada.

What constitutes a trick? Any technique or approach that lets you do something better, more efficiently or more cost-effectively. There are tips for every level of expertise from beginning to advanced. They are practical, philosophical, technical, whimsical, and always, in one way or another, informative. No trick will be new to everyone, but neither will any trick be known by everyone.

Although one chapter is called "Low-Budget Solutions," tips in every chapter address working on a low budget, saving money in prepress and printing, and finding inexpensive materials. You will find many innovative tricks for getting the most for clients on a low budget.

In addition to money-saving tricks and techniques, many of the tips are time-savers: techniques for working more efficiently with your software, ways to avoid output problems that will cost you both time and money, and suggestions on how to staff projects to streamline production.

The majority of tips were submitted directly by the contributors; others are reprinted from published sources and documents published on websites. Most of the tips have a contributor or credit listed after them. Any tips that are not credited were supplied by the authors.

The book is organized into ten topic chapters, with an exhaustive index to help you find information in a specific area. You can be linear and go to the table of contents, find the area that interests you most and turn to that chapter. You can be precise and go to the index to find a trick on scanning three-dimensional objects, using chipboard, or checking dot gain. Or you can take a completely random approach—pick up the book, open to any page, and see if there's a trick that's new to you.

Chapter One

INNOVATIVE DESIGN

AND USEFUL LAYOUT TRICKS

*I*f you're looking for ideas for your next brochure, thinking of redesigning your company's identity system or just getting started and need some page-layout help, you'll find something here: innovative designs that take an interactive approach to print; customizable, low-cost identity systems, multi-use designs. Many of the projects and tips in this chapter point to a common theme: Low budget-projects demand the best tricks and can be the source of the greatest creativity. If you're looking for a project to try out something new, start with your own identity system or your next self-promotion piece.

IDENTITY WITH A TWIST

It was difficult to get a consensus from a staff of designers on what our company logo should look like. We finally decided for obvious reasons that our logo should center around the letter "W." We developed a system with a twist of the old and the new that centered around correspondence. The stationery had aged edges, the business cards had personal signatures, and each designer could choose from a series of stamps from contemporary to traditional. Glycerin envelopes were used with the business cards to give the impression of a keepsake and make the recipient feel it was special. The system was designed to be constantly changing.

Willoughby Design Group, Kansas City, Missouri

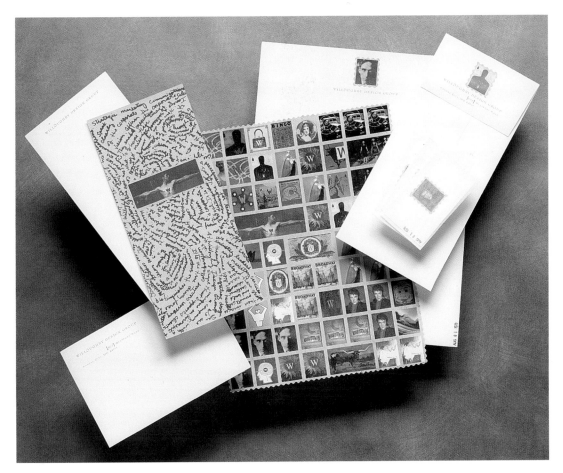

Willoughby Design Group identity system

CREATE A TEMPLATE COLLECTION

To help speed up the creative process, create a set of document templates for a tri-fold brochure, one-page flyer, postcard and so on. Make this collection as complete as possible, including font selections, number and size of images and tentative page layouts. You'll need to create several of each type of design so your designs don't all look alike.

POSTCARD DESIGN TIP #1: FRAME THE MESSAGE

When designing a postcard, put the most important message in the middle of the card, not in one of the corners. Draw attention to the message by "framing" it with something other than more text. For example, you can bracket it with clip art or a border.

CREATE VISUAL SURPRISE

Each spread within a design, especially a book design, should be a visual surprise. Carefully orchestrate your layout. Follow a quiet spread with a dynamic one. A large photograph bleeding two pages and crossing over the gutter might be followed by a collage of small photographs. A bright-colored, full-page photograph might be followed by a small, black-and-white photograph floating in a lot of white space.

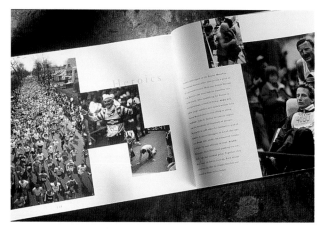

When laying out a book with a lot of text and photographs, vary the size of photographs and try grouping them on a page to create an interesting collage. This is a good alternative to the typical "textbook" layout of inserting many small photographs within your text blocks, which looks spotty and gets monotonous page after page.

Maureen Erbe, Principal, Erbe Design, South Pasadena, California

LOW-COST CATALOG

Brink Design creates imaginative items for the home—knick-knacks with purpose. Our objective was to design a piece to be distributed at a trade show and to potential clients, a pretty upscale group. We were given total design freedom, but on a very limited budget. Our solution was to do a tabloid-type catalog and print it at a traditional newspaper printer. This allowed us to print a large quantity of forty-page catalogs for minimal dollars. We used the theme "Think Brink" throughout, incorporating the products with heads or parts of people to reinforce their brand identity. The use of humorous, offbeat copy added to the playfulness of the catalog.

Willoughby Design Group, Kansas City, Missouri

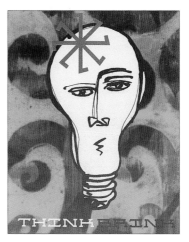

Brink Catalog, designed by Willoughby Design Group

TEXT FORMATTING: LINE LENGTHS AND READABILITY

Keep your line lengths eye-manageable. Less than five words per line of text is too short, no matter how large the type. Longer lines are okay, as long as the reader can easily scan from one side of the page to the other. When in doubt, format a few paragraphs of text in various typefaces, sizes and line lengths. Have a few friends scan the text. Ask them questions about its appearance and contents so you can see which combinations are easiest to read and create the best content retention.

CREATE A COLOR SAMPLER

Do you collect or buy paper samples? Create a color sampler book. Design a page that consists of lines of text in several typefaces and sizes and some graphics, both line art and grayscale. Print this specimen sheet on several colors and types of paper including white. Refer to your color sampler book to get an idea how the paper color will affect the text and graphics of your current project.

Jacci Howard Bear, JBdesigns, Austin, Texas. Excerpted from The INK Spot, *Vol. 2, Issue 2. The INK Spot On-Line can be found on the World Wide Web (http://member.aol.com/inkspotmag).*

MAKE PULL QUOTES STAND OUT

A pull quote can serve as a graphic element and call attention to an important statement in the text. To make a pull quote stand out on a page of text you can:

- Put a box around it.
- Use super-sized quotation marks around it.
- Make it a different color.
- Use a different typeface.

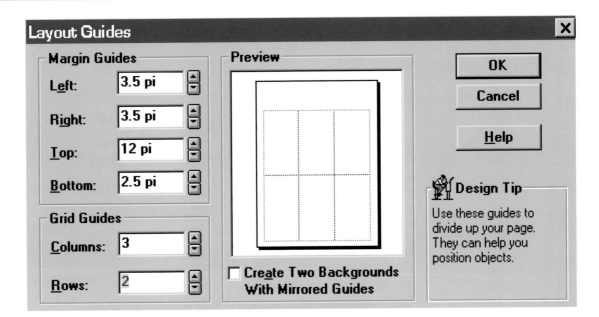

GRID-BASED DESIGN

Use a layout grid or layout guides for every design. Design the grid first and add text and graphics later. It helps speed up the design process and makes multiple page layouts more consistent. Use your page-layout program's snap-to-grid feature to easily line up design elements horizontally and vertically.

Creating a grid helps maintain consistency and speed up the design process.

UNIQUE GIFT IDEA

We designed fund-raising materials for an American Heart Association youth education program, using the theme "All Kids At Heart." The logo and theme reflect the purpose of the program—to educate Iowa's children about heart-healthy lifestyles.

We chose a "childlike" illustration style for the graphics of hearts and faces that appear throughout the collateral pieces. Components of the campaign include a case for support brochure—directed to individuals and corporations considering a contribution of $25,000 or greater—and a donor recognition gift.

Both the brochure and gift are presented in boxes that feature the hearts and faces graphics. The brochure box includes an insert tray with an enamel "All Kids at Heart" lapel pin. The unique donor gift is a tic-tac-toe-style game made from wooden blocks with red screen-printed graphics. Rather than "Xs" and "Os," the players use hearts and faces.

Sayles Graphic Design, Des Moines, Iowa

"All Kids at Heart" campaign, Sayles Graphic Design.

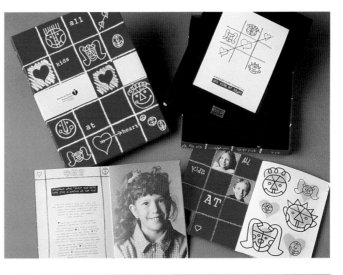

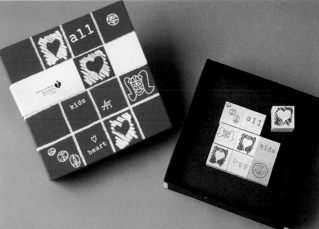

KISS-CUT STICKERS

When designing an invitation for a party, we wanted something that people could wear at the party. We originally wanted to use temporary tattoos, but time constraints prevented us from doing so. Instead, we kiss-cut round stickers (in the design we originally wanted for the tattoos) that people could wear and included them with the invitations. The idea was probably better than the tattoos because people were more inclined to wear them into the party.

Turkel Schwartz & Partners, Miami, Florida

TENGA A BIEN EXHIBIR SU CALCOMANÍA
EN LA ENTRADA, PORQUE SÓLO ASÍ
PODRÁ INGRESAR.

ADMITE A UNA PERSONA.
SERVICIO DE ESTACIONAMIENTO GRATIS
MARTES, 12 DE NOVIEMBRE DE 1996
21:00 HORAS
NO TRANSFERIBLE

When designing an invitation, Turkel Schwartz & Partners created a kiss-cut sticker for party-goers to wear.

ENVELOPE DESIGN TRICK

The Discover Channel Latin America was having a party. We produced the invitation which included two cards to get into the party and an envelope. We used French Construction stock in various colors for the pieces. Due to the time frame, we couldn't convert the envelope using the French Construction stock, but wanted it to complement the rest of the pieces. We came up with the idea to use a "pseudo-envelope" to hold the invitation so we could use the paper we wanted. The "pseudo-envelope" consisted of a flat sheet of paper scored in two places so it folded down at the top and up at the bottom. It held the invitation inside and was sealed with a mailing label to hold it closed. This worked because all the invitations were being sent via Federal Express so we didn't have to worry about meeting postal requirements.

Turkel Schwartz & Partners, Miami, Florida

Invitation and envelope designed for the Discover Channel Latin America by Turkel Schwartz & Partners.

KEEP IT SIMPLE

If information delivery is critical to your design's success, strip down to the basics.
- Avoid reversed type (readers skip over it).
- Avoid unnecessary punctuation like parentheses or brackets (readers get confused).
- Avoid dingbats and icons (readers misinterpret them).

Burkey Belser, Greenfield/Belser Ltd., Washington, DC

USE WHITE SPACE TO CREATE VARIETY

Use white space as a design element that changes from spread to spread. Vary the amount of white space to create interest on the spreads, just as you would vary the sizes of photographs to create interest. Some spreads may have very little white space, while others have a lot.

Maureen Erbe, Principal, Erbe Design, South Pasadena, California

BAR CODES DON'T HAVE TO BE BORING

Use your imagination when creating bar codes for clients. They can contain graphic messages as well as postal and other information. Here are a few favorites we've done for consumer packages. They were for a paper company, a tool company and a winery.

Rick Tharp, Tharp Did It, Los Gatos, California

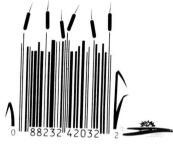

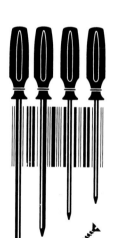

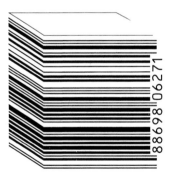

Bar code designs by Tharp Did It.

MAKE YOUR BOOK-DESIGN LIFE EASIER

If you're designing and laying out a book, make your life easier by specifying that chapters should start on the recto (right-hand) side of the page and that spreads will not bottom-align, i.e., that the baselines of the last lines on facing pages don't have to fall at the same level.

Kate Binder, Ursa Editorial Design, Rowley, Massachusetts

ALIGNING IMAGES ON FOLDED PANELS

To check the alignment of a graphic that appears partly on one flap of a brochure and partly on an adjoining folded flap, copy the inside panel. Cut and paste it (electronically) next to the flap it needs to match up with to make sure items such as bleed art, rules or color bands will align properly.

Cathy Cotter, Cotter Visual Communications, Landenberg, Pennsylvania

This year the world will be heading to Atlanta. And if your customers are among them, you could be taking home the Gold!

Training...

It's the key to Olympic victory. And it's also the secret to success for your customers. That's why we always encourage them to take advantage of training opportunities at our Atlanta facility.

And now we're providing you *and* your customers some extra incentive to hone their skills.

Each One ☆ Reach One

...But the winner will register many!

The more customers you register, the better your chances of being our top prize winner. What will it take to set the record — one registration a week? A day?

The best of the best will set the pace, because they'll *"go for the gold"* with every customer contact.

We're calling this sales contest "**Each One ☆ Reach One**" because one new registration per sales rep would be a great start in boosting our training enrollment.

But let's face it — it takes real effort and concentration to win an Olympic gold medal . . . and it'll take a lot more than one registration to win this contest.

So think of "**Each One ☆ Reach One**" this way:

- Analyze your customer base
- Match their needs to our course offerings
- Set a personal goal for number of registrations
- REACH that ONE personal goal!

If you need a list of courses to better target your customers, or if your customers need a 1996 Analytical Training Center catalog, call 1-800-227-9770.

Additional Contest Coupons can be obtained by calling the 800 number.

In a brochure Cotter Visual Communications designed for Hewlett Packard, the lines in the flag had to match up when the flap was folded.

SCALING ARTWORK

When scaling artwork, an easy formula to remember is: Final divided by actual equals percent change. Final (size that the art needs to be) divided by actual (size that the artwork is now) equals percent change. Say you have an image that needs to be 2 inches high in your layout. The source image is 5 inches high. 2(final)/5(actual)= .4 (percent change) or 40 percent. So the art needs to be scaled down by 40 percent.

Jym Warhol, MetaDesign, San Francisco

USING COLOR TO CONVEY INFORMATION

Used well, color can carry meaning and add another dimension to your ability to explain your subject.
- Use clear, bright colors for the information-bearing parts of your design and more subtle shades for the background.
- If you have to limit yourself to one color other than black, red is highly visible and works well in all its different shades.
- Be consistent. If you use gold to signify dollars in a graph on page 1, don't use green for dollars on page 3.
- Limit the number of colors you use. You want the most important information to stand out.
- Use color to identify repeating elements of your design so readers associate a certain color with a certain kind of information.

Adapted from The Basics of Color Design: Guidelines for Creating Color Documents, *published by Apple Computer, Inc.*

NO SMALL POTATOES

A major insurance client requested our design team develop a flat mailer for benefits managers across the country. The piece was to help change the perception at the time that the company's retirement products group was large and uncaring. In addition to a flat mailer, our creative team presented an object mailing—a box filled with small potatoes carrying the theme, "We'll never treat you like this." It drew a 50 percent response from the target audience.

Mel Maffei, Director, Keiler Design Group, Keiler and Co., Farmington, Connecticut

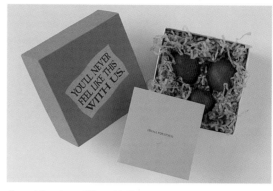

An object mailing Keiler Design Group designed for an insurance client got the attention of the company's customers.

COST-EFFECTIVE CUSTOMIZATION

The best lick for your buck! We wanted to be able to customize our collateral pieces as well as guarantee:
- variety
- freshness
- flexibility
- uniqueness
- cost containment
- a fun process

So we designed several miniature billboard-like stamps to use on everything from letterhead, envelopes, business cards, tags and labels to boxes, press releases, notecards and packages.

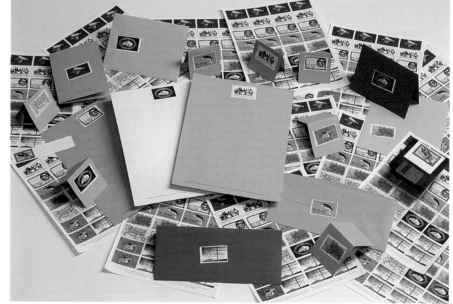

Palazzolo Design Studio's customizable identity system.

Initially, we almost abandoned the idea because it was becoming too expensive. Fortunately, we had a small trade-out account at a friendly print shop to pay for a portion. In hindsight, the program has been much more cost-effective than if we had gone with a standard two- or three-color package. We were able to use thirty-two stamps per sheet, and made 2,500 sheets. In other words, we'll be lickin' for a long time.

Gregg Palazzolo, Palazzolo Design Studio, Ada, Michigan

IMPORTANT CONSIDERATIONS FOR DESIGNING A LETTERHEAD

Before you choose the paper, production and printing techniques for your client's letterhead, consider the following:

• Select a paper and a production method that will run through your client's copiers and laser printers.

• Make sure your client's equipment can print on embossed paper before you incorporate an emboss into the design.

• Die cuts can also present problems if your client's printers or other equipment needs to grip the paper where a die cut has been made.

• Make sure the paper and production method are compatible with your design objectives. For example, a quick-print shop can't run a bleed design on 8½" × 11" sheets of paper. A job like this is best run on a larger press that can accommodate the trim required for a bleed.

• Make sure the quantity and production method you've chosen are compatible with one another. For instance, it would not be cost-effective to pay the prep charges on a multicolor letterhead for a quantity less than five thousand.

Reprinted with permission from Graphic Designer's Guide to Faster, Better, Easier Design & Production *by Poppy Evans, published by North Light Books.*

JAPANESE FOLDS CREATE A LITERARY FEEL

In designing a brochure for the Twin Farms Resort in Vermont, we wanted to convey the quality and class of the resort, but had very few photographs. By using uncoated paper and Japanese folds, we were able to create a sense of quality without slickness. In addition, the Japanese folds bulked up the brochure, allowing it to be perfect bound, which made it resemble a book more than a brochure and gave it a literary feel appropriate for the audience the resort wanted to attract.

KAISERDICKEN, Burlington, Vermont

Japanese folds made a brochure KAISERDICKEN designed for a Vermont resort feel like a book, conveying quality without slickness.

DESIGNING FOR MULTIPLE USES

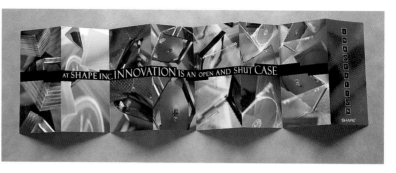

When designing, try to think of multiple uses for a piece, i.e., the handout that becomes a poster, the brochure that becomes packaging, or the catalog that becomes an identity piece. With plate changes, different trims or slight modifications, a well-designed piece can have added value for the client.

In this piece we designed for Shape, a manufacturer of CD packaging, the panels of the brochure were reused as packaging for CD cases and the design also served as a poster.

Leslie Evans Design Associates, Portland, Maine

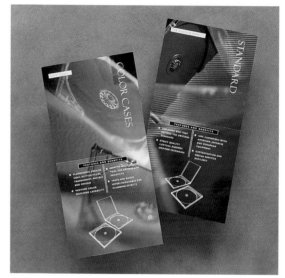

Leslie Evans Design Associates made multiple uses of one design in a piece for Shape, a manufacturer of CD packaging. The panels of an accordion brochure become packaging for different products in the company's line.

CHOOSE PAPERS FOR FOLDED BROCHURES EARLY IN THE PROCESS

When you're designing a folded brochure, work on your paper selection early. The type and number of folds will play a major role in determining what paper will work best. Some stocks are too heavy to be folded and scored effectively. If the piece has more than three or four panels, it will be difficult to fold at all—much less correctly—by the time the final fold is made. The weight of the piece and the cost of mailing it is another consideration. Balance weight and foldability against sturdiness, especially if the brochure will be handled extensively by the recipient.

The best way to choose paper for a folded brochure is to choose several papers that suit your reproduction requirements and then have a paper dummy made of each. This will let you see how each paper performs when folded to your specifications. You can also take dummies and envelopes to the post office and have them weighed to determine your mailing costs.

Reprinted with permission from Graphic Designer's Guide to Faster, Better, Easier Design & Production *by Poppy Evans, published by North Light Books.*

MEETING THE CHALLENGE

When Public Radio International (PRI) asked us to design their 1995 annual report, it was budgeted as a two-color project. Funding for public radio was low. PRI summed it up in its design brief by saying that 1995 was a year of "challenge and change." Noticing that the word "change" was contained within "challenge," we framed the PRI story around this theme and it became our cover solution.

Because the annual was a fairly short run, we knew we could use processes and materials that would be prohibitive on a large scale. And because the book was running more than sixteen pages, we would be using multiple press forms. This gave us the options of changing our second ink color and changing the paper stock. We did both. We chose black ink for the entire run, with red and the trademark PRI green as our secondary inks, and we used both white and ivory paper. Using a wire-o binding gave us the option of mixing up the ink and colors even further. We cut the back financial pages into half pages for a barn-door arrangement that gave the piece even more variety. The front cover and financials are printed black and blind debossed to read CHA-lle-NGE and resOURces. The extra time put into stretching the two-color concept paid off handsomely in the end product.

Steven Sikora, Design Guys, Minneapolis, Minnesota

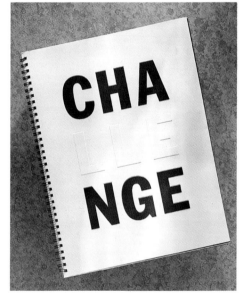

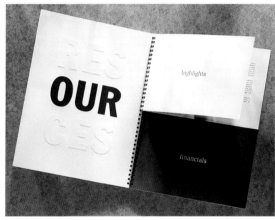

Blind debossing gives the words "challenge" and "resources" double meanings in the annual report Design Guys designed for Public Radio International.

A RULE FOR RULES

Don't use your page layout software's default hairline width rule. The exact width of a hairline rule varies from program to program and output device to output device. Your laser printer may use one width and the service bureau's imagesetter another (thinner) width. Define your own hairline width as .25 point.

Taken from material provided by the Scitex Graphic Arts User Association.

SHADING IN TABLES INCREASES READABILITY

If a table has more than four rows, shade every other row to make it easier for the reader to scan horizontally across the table. Use the same percentage of color or gray for all shaded rows, unless you want to highlight one row in particular. Even if you are printing in color, consider using gray shading instead of a color tint. Black text on a light gray background is easier to read (and less troublesome to print) than colored tints and text. Keep in mind that you may need to use a darker shade (higher percentage) of gray than looks correct on your laser page proof if the final output will be on a imagesetter. The higher the resolution, the lighter the same gray percentage setting will look.

INTERACTIVE COMPONENTS CONVEY A NEW IMAGE

The Lee Company needed an image piece to send to movie and TV stylists. It was important to show the new, updated look of the Lee products, and the piece had to have lasting impact. We decided on a multipage spiral book that fit into a bookcase. We broke it into three different looks—Urban, Retro and Natural—to reinforce the variety of looks that could be achieved with Lee products. Throughout the piece we incorporated interactive components in the form of pullouts, a poster, postcards and a notepad.

Willoughby Design Group, Kansas City, Missouri

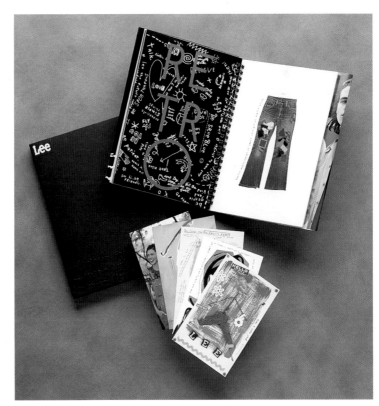

The image piece Willoughby Design Group created for Lee includes interactive components such as a notepad and postcards packaged in a glycerin bag.

DESIGN CHOICES: USE WHAT YOU HAVE TO CREATE THE RIGHT FEEL

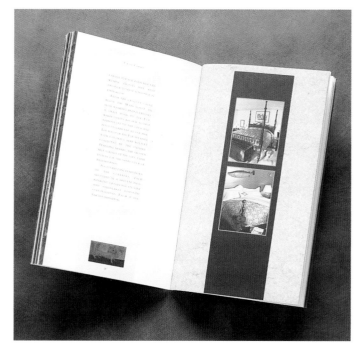

Two brochures designed for the same resort show the different effect of using a combination of illustrations, quotes and photographs on uncoated paper (left) vs. straight photography on coated paper (below, left). For the second brochure, the warmth and naturalness of the cover offset the slicker interior (below, right).

We designed two different brochures for the Twin Farms Resort. For the first brochure, we used uncoated paper. We didn't have many photographs because the resort was under renovation, so we created the feel of the resort using a combination of the available photos, illustrations and the paper stock itself. The second brochure, which uses coated paper for the interior, features a lot of photographs. This is a more traditional approach for resorts—to sell rooms through photographs. The different results and the feelings created by printing on coated and uncoated papers can be seen here.

KAISERDICKEN, Burlington, Vermont

GUTTER MARGINS FOR BOUND DOCUMENTS

If the document you're designing will be bound after printing, take this into consideration. When you set up your pages, leave extra room along the edges so the binding won't cut into the print. Do this using the gutter margin setting in your software rather than making the left margin wider than the right. Sometimes you need extra room on the left side of the page and sometimes you need it on the right. The software will make the necessary changes if you use the gutter margin.

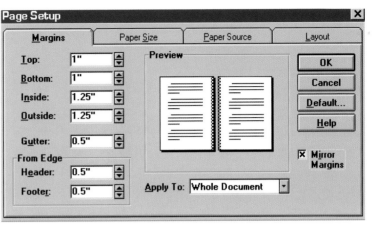

Use the gutter margin setting in your page-layout software to leave extra room for binding.

MASTER PAGES KEEP PROJECTS CONSISTENT

Always use master pages and style sheets where possible, even for small projects like business cards. They'll make it much easier to keep a project consistent with the original design throughout its lifetime. In addition, other people working on the files will be able to follow your design concept more easily.

Kate Binder, Ursa Editorial Design, Rowley, Massachusetts

POSTCARD DESIGN TIP #2: LIMIT THE MESSAGES

Because of the limited amount of space on a postcard, limit yourself to no more than two messages for a large card and one for smaller cards. Cramming information on cards practically guarantees the reader won't remember your messages. It's better to use two cards mailed at the same time than to put everything on one card.

BREAK THE GRID

Carefully formatting your design and creating a tight grid is an important organizational tool, but adhering to your format or grid too tightly can be boring page after page. Don't be gridlocked! Grids are made to be broken. An unexpected deviation from the grid can inject tremendous visual interest into a spread.

Maureen Erbe, Principal, Erbe Design, South Pasadena, California

LETTERHEAD DESIGN: FAX BEFORE YOU FINALIZE

If you often fax your letterhead, run the proposed design and the proposed paper through the fax machine to see the quality of the faxes. Recycled papers sometimes look too dirty when faxed to be read correctly. Some colors fax as dark gray, reducing readability and increasing fax transmission time.

Cathy Cotter, Cotter Visual Communications, Landenberg, Pennsylvania

INTERACTIVE POSTER DESIGN

Public Radio International wanted us to design a poster for a series of documentaries—on a very low budget. By designing six flaps to hold information about the six parts of the program, we made the poster three-dimensional and interactive. The flaps, attached to the base poster, are all fragments of the poster image printed on different paper stocks during the same press run. When the viewer lifts the flaps, she can find out more about the content of the individual programs. The poster and flaps were printed in just two colors.

Steven Sikora, Design Guys, Minneapolis, Minnesota

A poster Design Guys created for Public Radio International uses flaps attached to the base poster to hold information about individual programs.

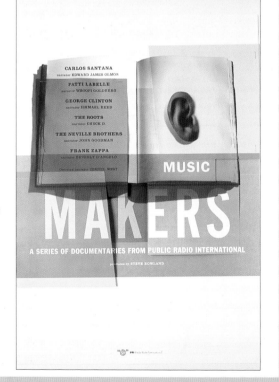

IRREGULAR FOLDS FOR A DYNAMIC FEEL

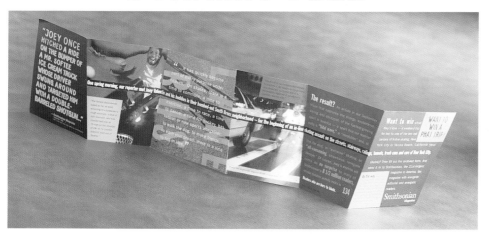

Carol Bokuniewicz Design's brochure for *Smithsonian* magazine.

To promote an article on rollerblading, a brochure that was part of a direct-mail campaign for *Smithsonian* magazine had to have an irreverent, aggressive graphic treatment. Using irregular folds gave it a rebellious feel without using expensive printing techniques. The inexpensive, simple folding technique employed here creates a three-dimensional feel. The brochure is a straight-cut sheet of paper, scored at irregular angles to create an unexpected shape when it folds.

Carol Bokuniewicz, Carol Bokuniewicz Design, New York City

ALTERNATE WHITE AND COLOR PAGES FOR CONTRAST

Contrast solid pages with full ink coverage against very white pages to create visual interest.

Maureen Erbe, Principal, Erbe Design, South Pasadena, California

POSTCARD DESIGN TIP #3:
USE THE FRONT OF THE CARD

Use the space on the front of the card for additional messages or design space. This is particularly cost-effective if you will be printing a return address on the front of the card anyway. If you are designing a card that will be mailed outside of the United States, find out about postal regulations for the positioning of text and images on a postcard in the countries to which it will be mailed.

TYPE

CREATION, USE AND MANAGEMENT

Designers have more control over typography than ever before, but with that comes responsibility. Not only must they think about making the most effective use of type, they must also think of the production side: Will reversing the type create a great look but make the text impossible to read? Is there enough contrast in the type color for it to show up against the tinted background?

In addition, given the number of fonts from different manufacturers that design firms own and use regularly today, font tracking and management is a big issue. A number of tips in this chapter address keeping track of your fonts for both in-house use and for output at a service bureau.

CREATING A NONLINEAR READING EXPERIENCE WITH TYPE

Although books are often held as the model for linear reading in contrast to the nonlinear experience of multimedia, reading books doesn't have to be a front-to-back, top-to-bottom experience. The design for a book on the history of Harley Davidson was intended to make the reading process more pleasant by giving the reader options as to where to start reading. This was accomplished by using a variety of styles and sizes of the same typeface on each text page and keeping a lot of white space. In this way, the reader's eye is drawn to move around the page rather than start at the beginning of a block of text and read from top to bottom. I carefully selected the two typefaces, Beowulf for the headline face and Centaur for the body, because I wanted the type to be very clean.

Carlos Segura, Segura, Inc., Chicago

TOGETHER, THESE WONDERS OF THE

TIMES, COMBINED WITH HUNDREDS AND

THOUSANDS OF OTHERS IN THAT ERA,

WOULD COMPLETELY CHANGE PEOPLES'

PERSPECTIVES ON THE WORLD.

The Motorcycle that

Wasn't a Bicycle: 1903-1908

Varying the size and style of the body type in a book on the history of Harley Davidson gives the reader options of where to start and how to read.

ANATOMY OF A TYPEFACE

Before you create your own typeface, you must first have a good understanding of the anatomy of a typeface. Test your knowledge of typeface anatomy by identifying the following "body parts" on the sample at right.

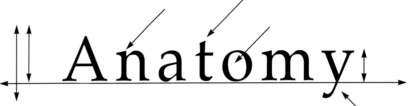

See if you can assign the following type terms to the "body parts" indicated by the arrows: ascender; baseline; cap height; counter; descender; point size; serif; x-height.

DESIGN WITH THE FINAL OUTPUT DEVICE IN MIND

It's OK to check the progress of your font design work by printing the faces on a laser or inkjet printer. Be sure, however, to periodically print type samples on the final output device during the design phase. If the final output device is an imagesetter with a print resolution higher than your laser or inkjet printer, the type produced by the imagesetter will look thinner and lighter than the output from lower-resolution devices. This is particularly true for thinner areas of the face including descenders and serifs.

LARGER TYPE FOR BLIND EMBOSSING

If you're designing a piece that will be blind embossed, make sure to compensate for the fact that blind embossing has a tendency to make type look like it has shrunk a point size or two. Try making your text a point size larger than normal. See if you can get the printer to produce some embossed samples of the design before you commit to it.

TYPE ELEMENTS AS DESIGN ELEMENTS

Use captions, folios, pull quotes, chapter heads and callouts as important design elements. Typography can be beautiful, and it's as important as images and text in bringing the reader into the book. Contrast typefaces and type usage of these elements. Use type like a stylistic element throughout, being careful to maintain readability. Be creative, contrast roman type against italic, sans serif against serif, open letterspacing against normal letterspacing. Vary the type color in this same manner for contrasting information.

Maureen Erbe, Principal, Erbe Design, South Pasadena, California

TYPE: A SUBCONSCIOUS PERSUADER

Type attracts attention, sets the style and tone of a document, colors how readers interpret the words, and defines the feeling of the page—usually without the reader recognizing the particular typeface. Keep the following in mind when choosing a typeface:

• Type is image. Type can reinforce your image as a company or individual. If you use it consistently, people will start to associate you with a certain typeface. They might find themselves thinking of you when they see that typeface, without knowing why.

• Type is power. Type has an effect on you even if you don't consciously notice it. You can use this power to your advantage to attract attention, strengthen your message and improve your image, or you can overlook it and work against yourself by saying one message with your text and conveying another with your font.

• Type is important. The right typeface can encourage people to read your message. The wrong typeface or bad typography can make your message go unread.

Excerpted from Choosing & Using Type *by Daniel Will-Harris. This document can be found on the World Wide Web (http://www.will-harris.com).*

CHOOSING A TYPEFACE

When you're stuck on the typeface-choosing step of a project, try narrowing your choices by using one serif face and one non-serif face. Generally, the former is appropriate for text and the latter for heads.

Kate Binder, Ursa Editorial Design, Rowley, Massachusetts

DESIGNING LETTERS FOR A DISTINCTIVE LOOK

When you want to create a typeface for a logo or letterhead, you don't have to create a design for an entire family of type. You can design just a few letters to give a distinctive look to corporate logos and letterhead. Using a few specially designed letters is easier than creating the letterforms as graphics over and over again.

INCREASING THE READABILITY OF REVERSED TYPE

Avoid reversing out type with thin serifs, such as Garamond or Copperplate. The serifs can disappear entirely when the page is printed due to dot gain. If you must use such a typeface, make the type size of the reversed type one or two points larger than the regular (nonreversed) type.

TYPE USAGE IN BOOK DESIGN

Create a different type treatment for the first page of a chapter to create visual interest and draw attention to the new chapter.

Maureen Erbe, Principal, Erbe Design, South Pasadena, California

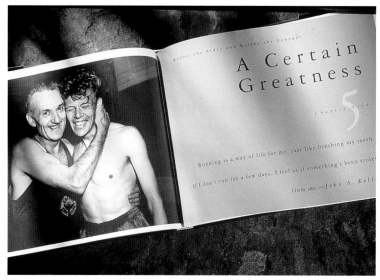

The opening page of a chapter in the book *Boston: A Century of Running*.

TYPE STYLES TO AVOID IN ADDRESS PRINTING

When designing envelopes to be read by optical character readers, the United States Postal Service recommends using simple sans serif fonts. Avoid type styles defined as light, bold, extended or condensed, as well as type styles that contain numbers likely to be misread (such as fonts that contain "flat-top" threes). Italic, highly stylized and script fonts should also be avoided.

REWORKING LINE BREAKS IN JUSTIFIED TEXT

Here's a useful trick when reworking line breaks in justified text: Place the cursor anywhere in the paragraph and temporarily set the alignment menu to flush left. The paragraph will now display as ragged right, making it much easier to spot the short lines and evaluate the spaces available to work with. Once the paragraph is rebroken, rejustify it and check the result.

Joe Kotler, President, Moveable Type, a Toronto, Ontario-based typesetting and prepress shop. Based on material published in Applied Arts Magazine, *November/December 1996.*

OBJECTS AS LETTERFORMS

Add some zest to your text by using an object to suggest a letterform. For example, a clip art image of a mushroom could be used in place of a capital "T." To avoid confusing the reader, make sure the object clearly suggests the letterform. You may have to edit the object to make it look more like a letter.

TYPE IN TRANSLATION

Many languages other than English have accents, umlauts, tildes and other typographic miscellany that will affect your line spacing. Allow time to adjust the leading of translated type to compensate. For documents and designs that will be printed in several languages, don't use knockout type printed over color images because you'll have to create new color separations when you translate your art into other languages.

Reprinted with permission from "Tech Tips" by Constance Sidles, HOW magazine, April 1996.

PLAN THE MOOD

Before starting a typeface design, decide the mood or tone you want the completed design to evoke or set. Doing so will go a long way toward helping you decide what the basic characteristics of the typeface should be. Here are some examples:

Mood	Characteristics	Example
Light-hearted	Thin strokes, short serifs	Life is just a bowl of cherries.
Somber	Right angles, straight lines of medium thickness	**Never a borrower nor a lender be.**
Official	Rectangular or narrow letter forms, sans serif or small serif	The rules must be obeyed.
Sensual	Rounded, softly curved lines, long serifs	A Font to Remember.
Casual	Short serifs, irregular letterforms	No Shirt, No Tie, No Socks Required.

TREAT LABELS LIKE LITTLE SIGNS

Paragraphs of text are most easily read in a serif font. But sans serif fonts are the preferred families for clear labeling. Labels are really reduced signs, and it is for a good reason that most signage systems use the international type style of sans serif Helvetica: A simple sans serif font is easier to read from a distance than a serif font.

Burkey Belser, Greenfield/Belser Ltd., Washington, DC

Nutrition Facts
Serving Size 33 crackers (30g)
Servings Per Container about 8

Amount Per Serving

Calories 130	Calories from Fat 30
	% Daily Value*
Total Fat 3.5g	**5%**
Saturated Fat 0.5g	**3%**
Polyunsaturated Fat 1.5g	
Monounsaturated Fat 1g	
Cholesterol 0mg	**0%**
Sodium 390mg	**16%**
Total Carbohydrate 22g	**7%**
Dietary Fiber 0g	**0%**
Sugars 2g	
Protein 2g	

Vitamin A	0%	•	Vitamin C	0%
Calcium	0%	•	Iron	2%

Labels are like reduced signs, so the typefaces used for them should be sans serif like those used in signage.

USING OLD-STYLE FIGURES

For a classy look, consider using old-style figures when they're available in the typeface you've chosen. Lining figures, the familiar numbers that share a common cap height and baseline, are much more common than old-style figures. However, old-style figures were originally designed to mix well with text because they vary in height and some descend below the baseline, adding aesthetic appeal.

Kate Binder, Ursa Editorial Design, Rowley, Massachusetts

ASSOCIATIONS

Companies often create a corporate design identity by using the same fonts or combinations of fonts. Look for the fonts and font combinations next time you see materials from that company. You may choose to use the same fonts and combinations in your designs. Be aware of the possible conscious or unconscious associations you will evoke in the minds of your readers or clients.

TURN OFF EXTENSIONS WHEN DESIGNING IN FONTOGRAPHER

When creating typefaces in Fontographer you should turn off your extensions. If you don't, the typefaces are likely to be corrupted when you save them.

Betsy Kopshina, GarageFonts, Del Mar, California

FONT TRACKING

If a service bureau or quick print shop is going to output a file for you, you should send the font files for a document along with the document file. You can do this by keeping track of the fonts manually or by using a font tracking utility. Some of the utilities will search your file, automatically collect all the necessary fonts and even produce a printed report you can send along with the document files.

Using a font-tracking utility helps ensure that all of the fonts are included when you send a document to a service bureau.

FontXPress Preferences

☐ Search all disk(s) without asking

☐ Include standard 'System' fonts

☐ Automatically open file on start up

[Select Fonts Folder For Search]

Currently Selected Folder:

MorrisonMac2:System Folder:Fonts:

○ Collect fonts individually

● Collect fonts into a new suitcase

[Save] [Cancel]

MANAGING FONTS IN PC FILES

Keeping track of fonts and preparing font files for output for PC graphics files can be frustrating. Using a font management program that permits you to create font bundles and transfer them to a disk with your output files will help ensure that all necessary fonts are included.

Rebecca Ranieri, Faith Writing and Design Studio, Norristown, Pennsylvania

REVERSING TYPE OUT OF A BACKGROUND COLOR

When reversing type out of a background color, be sure there is at least a 30 percent difference in tonal value between the type and the background. Use a gray scale to check the value. Pay close attention to a bright background color, which will create the illusion of more contrast than really exists.

Reprinted with permission from Graphic Designer's Guide to Faster, Better, Easier Design & Production *by Poppy Evans, published by North Light Books.*

USING COLOR TYPE

Black on white is the most legible combination for type. However, if you want to add color, experiment with the following tricks to get the best effect.

- Use colored type for headings, not for text.
- Make sure there's a contrast between the shades of the background and foreground colors. If the type and the background are equally dark or light, the type will be very hard to read.
- Try using two or more shades of the same color, one for the type and one for the background—a light and dark green, for example.
- Add white or black to the shade of your background to improve the contrast between the background and the text.
- Don't print large blocks of text in light colors. Light-colored text is hard to read.

Adapted from The Basics of Color Design: Guidelines for Creating Color Documents, *published by Apple Computer, Inc.*

TYPE IN TABLES

For type in a table with columns, use the narrow version of a typeface. For example, you may use Arial Narrow for a table and Arial for the rest of the document. Using the narrow version of the typeface means you don't have to kern a regular width typeface in a table, which takes too long and is very difficult to do correctly.

CHARACTER SPACING IN MAILING ADDRESSES

An optical character reader needs to see a clear vertical space between characters in order to accurately identify each one. Spacing between ¾ point and 3 points is acceptable. One-point character spacing is recommended. Kerning, on the other hand, should not be used when printing address information.

Excerpted from the United States Postal Service publication Designing Business Letter Mail.

DISTRESSING TYPE

Want to give your type a distressed look? Here's an easy way to do it:
1. Run a laser print of the type.
2. Crumple the laser-printed paper until the desired effect is achieved.
3. Scan the crumpled paper.

Leslie Evans Design Associates, Portland, Maine

CREATING A THREE-DIMENSIONAL LOOK WITH TYPE

For the 1995 Columbus Society of Communicating Arts Commemorative Catalog, on pages that were all text, we gradually reduced the size of the type as it went down the page and printed alternating lines in different colors, including metallic. The "terraced" type gives the reader the illusion of depth and creates an interesting visual effect when combined with the metallic ink. The font used was Helvetica Neue Condensed.

Kirk Richard Smith, Firehouse 101 art+design, Columbus, Ohio

The type on this spread for the 1995 Columbus Society of Communicating Arts Commemorative Catalog is gradually reduced as it goes down the page, creating a three-dimensional effect. The use of metallic contributes to this effect, making alternating lines stand out depending on the angle from which you look.

SCALING VS. TRACKING

Many designers rely solely on reduced tracking when wrestling with a stubborn line break. The result can be a very tight line that clashes visually with the rest of the paragraph. Usually scaling is the better choice. By simultaneously tightening the letter and word spacing and narrowing the character widths, a relatively small adjustment can often do the trick and be far less noticeable. Sometimes a combination of tracking and scaling can help avoid exaggerating either effect. But there are no hard and fast rules: Experimentation and experience are the best teachers.

Joe Kotler, President, Moveable Type, a Toronto, Ontario-based typesetting and prepress shop. Based on material published in Applied Arts Magazine, *November/December 1996.*

TEXT ON TINTED PANELS

When using text on tinted panels, make sure the color contrast between the text and the panel tint is high enough. This is particularly important if you're using different shades of the same color or closely related colors for the text and tint. Tinted panels can become darker when printed because of dot gain.

GETTING THE BEST BREAK

Today's layout designers have a degree of control over text setting that is beyond the reach of yesterday's typographic experts. But breaking text appropriately still requires manipulation and massaging based on some basic typesetting standards.

Each of the two main styles of setting text, ragged right and justified, has its own aesthetic requirements. The basic rule for ragged right text is to alternate long and short lines. This gives the text columns an even appearance and avoids the distraction of awkward shapes along the right-hand edge. That is the goal, but a slew of other considerations also come into play: minimizing hyphenation, avoiding widows (single words at the ends of paragraphs), breaking for sense, avoiding breaking proper names and so on. The trick is to balance these imperatives and, when they cannot be reconciled, to choose the lesser evil—usually the least visually distracting alternative.

Joe Kotler, President, Moveable Type, a Toronto, Ontario-based typesetting and prepress shop. Based on material published in Applied Arts Magazine, *November/December 1996.*

ADD FREQUENTLY USED CHARACTERS TO FONTS

To save time and trouble, add frequently used characters, such as logos, symbols and even graphics to your fonts. By doing so, you'll be able to include these special characters in documents just by hitting a few keys. Check for font creation and management utilities you can use to add new features to an existing font.

CHANGE TYPEFACE TO ADD EMPHASIS

Change to a different typeface to draw attention to or add emphasis to an entire block of text. Using italics is fine for a single word or to indicate the title of a work. It is easier to read a paragraph set in a different typeface than it is to read the same text in italic.

TAKING STOCK

Take stock of the typefaces you have on hand. Categorize them by:
- platform: Macintosh, PC
- possible uses: body text, headlines
- type: PostScript, True Type
- style: serif, sans serif
- possible combinations: Galliard for body text and Garamond for headlines

Knowing what typefaces you have in your "inventory" will help you spend your typeface dollars more wisely.

TYPOGRAPHERS STILL EXIST: USE THEM

When we have books or multiple pages of text to compose, we use a typographer. Yes, a few of them still exist, and the savvy ones now have Macintosh skills. The type is always better when set by someone with years and years of experience. Besides, it frees us up to do what we like to do best—design.

Rick Tharp, Tharp Did It, Los Gatos, California

EXPERIMENT WITH CHARTS AND GRAPHS

Charts and graphs can be a great excuse to experiment with typography. Make use of different typefaces and different typesetting techniques to draw out information, contrast roman type against italic and sans serif against serif, vary letterspacing, or use old-fashioned numbers.

Maureen Erbe, Principal, Erbe Design, South Pasadena, California

ADJUSTING TYPE

Try to avoid horizontally or vertically scaling type. Doing so alters the relative proportions of the strokes in the letterforms. On the other hand, feel free to adjust kerning pairs where possible for a more professional look (if done within a page layout program, this doesn't alter the font file itself).

Kate Binder, Ursa Editorial Design, Rowley, Massachusetts

TREATING TEXT GRAPHICALLY

By treating text as a graphic, you can dramatically alter its appearance. Start by creating the text in a drawing program and exporting it as a graphic. Open the graphic in your favorite image editing program and experiment with the image editing capabilities. Once you're done, you can save and use the image as you would any graphic.

The easiest and fastest way to produce something unusual is to erase parts of the letterforms and fill the erased areas with colors, textures and fills. Make sure not to erase through the edge of the letterform. If you do, your fill will spill out of the letter's shape and fill the background.

PHOTOGRAPHY

SHOOTING, CHOOSING AND USING THE BEST IMAGES

The options for designers looking for or assigning photographs have grown exponentially in the last several years. Today, in addition to the conventional choices of having images shot by a photographer for a specific assignment, doing their own photography or ordering from a traditional stock photography company, designers can also find images on hundreds of Photo CD collections, on the World Wide Web or from any number of public-domain sources. This chapter features recommendations from photographers on how to get the most out of a shoot, tips from designers on using photos effectively in layouts, information on using Photo CD images, and some tricks for achieving special effects.

INFORMATION TO GIVE A DIGITAL PHOTOGRAPHER

Let the photographer know the printing process, type of paper, dpi, total ink coverage and dot gain before photographing the image. All of these will determine the work done on the digital image. Tell the photographer the exact size of the image you want. If the image needs to be resized, send it back to the photographer unless you are a digital photography expert. Ask for a low-resolution file to use for positioning.

Jeff Kauck, Kauck Productions, Cincinnati, Ohio and Chicago, Illinois

Digital photography can give designers and photographers greater control over the outcome if the photographer has as much information as possible up front.

RIPPLE EFFECT

Try using ripple glass to create a waterfall effect in your photographs. Place a sheet of ripple glass (available at photography supply houses) in front of the object you want to photograph and shoot the photograph through the glass.

Baldo Photography, Phoenixville, Pennsylvania

Using ripple glass creates a waterfall effect in photographs.

© 1996 Don Baldo

RESOLUTION IN PHOTO CD IMAGES

Most Photo CD acquisition software brings images in at 72dpi, regardless of the resolution you've selected. Only the dimensions will vary. Therefore, be sure to convert the image to the desired resolution using an image manipulation software package. Increasing the resolution will decrease the dimensions of the image proportionally.

Taken from The Official Photo CD Handbook, *produced by Michael Gosney with Ray Baggarley, Jackie Estrada, Bill Hurter, Amy Stone, Mark Kaproff and Brian Lawler.*

EQUIPMENT ANXIETY AND DIGITAL PHOTOGRAPHY

If you want to work with digital photographers, but are concerned about your equipment's capacity to handle high-resolution images, stop worrying. If you're confident about your photographer's abilities, you only need enough computer power to read and manipulate low-res FPO files. And although many photo files are far too large to modem quickly (some software creates 500MB images), FPO files don't take long to transmit and full files can be couriered overnight.

Excerpted from the article, "Joining the Digital Photography Revolution," by Gail Deibler Finke, HOW *magazine, August 1995*

A CHECKLIST FOR PHOTOGRAPHIC PRINT QUALITY

Use this checklist to guide you in selecting photographs for reproduction. For best results, the photographs should encompass the following qualities:

• Be in sharp focus. Order a working print near in size to the final size of the photograph to check focus.

• Have adequate contrast. Make sure there is enough of a tonal range within key elements and overall between the lightest and darkest areas.

• Have a fine grain. The finer the grain of the photograph, the better, especially if you are going to enlarge the shot a great deal.

• Have strong highlight and shadow detail. Tell the printer which details can be sacrificed and which must remain.

Condensed from the S.D. Warren book, A Team Approach to Photography for Reproduction.

WORKING WITH PHOTO COLLAGES

Combine a quote and a symbolic word with photographic collages to capture the spirit of the text on a facing page. Such collages are quick and easy to read and support the running text, yet also stand alone to tell their own story and break up heavy text pages.

Maureen Erbe, Principal, Erbe Design, South Pasadena, California

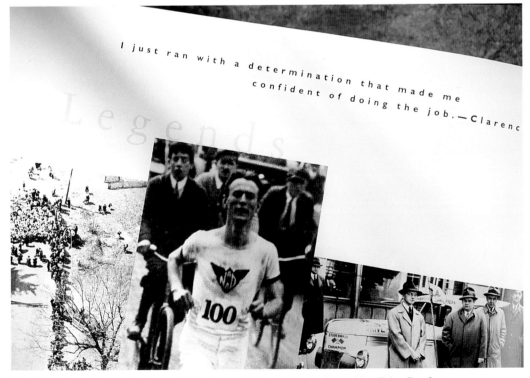

I just ran with a determination that made me confident of doing the job. —Clarenc

Photo collage from *Boston: A Century of Running*, designed by Erbe Design.

WHAT TO LOOK FOR IN A PHOTOGRAPHER'S PORTFOLIO

When reviewing a photographer's portfolio, look for the person's vision—what common thread holds the book together? Ultimately, that is what you're going to get at your shoot. If the portfolio is all over the place stylistically, chances are you can't count on anything for sure. Don't assume that you can get something out of the photographer you don't see. On the other hand, it's *not* important to see the exact shot you want already in the portfolio, but rather to look at the photographer's work as a whole. Is it clean, gritty, creative, problem solving, romantic, boring? . . . These are the kinds of questions to ask yourself. Also pay attention to presentation. It is a direct reflection of how the photographer views his or her own work.

Stephen Hellerstein, photographer, New York City

SILHOUETTE SECRET

If you're photographing an object or a number of objects that will be silhouetted, photograph against a background color that doesn't appear anywhere in the subject. The background color can be easily removed electronically, leaving a clean, sharp edge around the object. This approach works particularly well if you want to use one background behind a number of different objects but different photographers are working on the project. Once you remove the photographed background, you can substitute the same one electronically on all the photographs.

Reprinted with permission from "Tech Tips" by Constance Sidles, HOW magazine, June 1995.

BUDGET PHOTOGRAPHY SOURCES

National, state and local government offices are good sources for low-cost (or free) images. Among the national government sources are the following:
- The National Archives and Records Services
- The Library of Congress
- The National Park Service
- NASA

The following local and state agencies may provide photographic materials:
- Chambers of commerce
- State and local offices of tourism

Universities and trade associations are other possible sources to check for photographs.

Adapted with permission from Graphic Designer's Guide to Faster, Better, Easier Design & Production *by Poppy Evans, published by North Light Books.*

ADD TEXTURE TO YOUR PHOTOGRAPHS

You can add texture to photos in a photo manipulation program. First combine a texture, such as fabric, with an image and then ghost one over the other. The cover of a brochure we designed for Cambridge Dry Goods uses an image that was ghosted in this way.

Leslie Evans Design Associates, Portland, Maine

A brochure Leslie Evans Design Associates designed for Cambridge Dry Goods uses an image of a piece of fabric ghosted over the background image to give the cover texture.

CREATING A WIN-WIN SITUATION ON A SHOOT

If there's a difference of vision between the art director and the photographer on a shoot, there's a simple way to solve it: Shoot it both ways.

Stephen Hellerstein, photographer, New York City

Enhance or change the look of a scanned photograph by framing it digitally. You can frame it with a simple box or oval. Clip art frames are available as well. You can even fake a frame by erasing or blurring the edges of the photograph using image retouching or editing software. In addition, some software programs provide different edge and other effects.

MAKING THE MOST OF BLACK-AND-WHITE PHOTOGRAPHS

Make sure the message conveyed by a black-and-white photograph is a strong one. Black-and-white photographs don't have the benefit of color to create interest and help organize the viewer's eye. So, a black-and-white photograph must have exceptional composition and a powerful concept.

Condensed from the S.D. Warren book, A Team Approach to Photography for Reproduction.

SUSPENDED OBJECT TRICK

To make objects look as if they are suspended in air, lay them on a thin sheet of clear glass. Place a sheet of translucent paper (colored or white) under the glass and light the paper from underneath.

Baldo Photography, Phoenixville, Pennsylvania

USING SCANNED PHOTOGRAPHS TO CREATE TEXTURE

You can use a photograph of a textured natural object to create a background. We photographed tree bark and scanned it, then printed it on uncoated paper as the background for the cover of an Adirondacks resort brochure.

KAISERDICKEN, Burlington, Vermont

LAKE PLACID LODGE

GET A NEW PERSPECTIVE

Pairing up a photographer with an assignment that is totally out of his realm can yield terrific results. For example, have a fashion photographer shoot a car assignment. If what you're looking for is a new perspective or vision, the results could be awesome.

Stephen Hellerstein, photographer, New York City

DIGITAL PHOTOGRAPHY: HANDS OFF THE HIGH-RES FILE

Never touch the high-res file. The proof and the FPO file are all you need. It's better to tell the photographer the changes you want to make and let him or her take care of it. It will save you a lot of time and frustration.

Jeff Kauck, Kauck Productions, Cincinnati, Ohio and Chicago, Illinois

METALLIC OBJECTS AS IMAGES

Producing good photographs and prints of metallic objects takes expertise and planning. Many metallic objects behave like mirrors and reflect whatever surrounds them. Photographs of such objects must have sharp contrasts between highlight and shadow. Both photographer and printer must have experience dealing with such objects and resultant images.

Condensed from the S.D. Warren book, A Team Approach to Photography for Reproduction.

GARBAGE IN, GARBAGE OUT

Take your own shot or work on a stock image and you'll be spending lots of time working in Adobe Photoshop. Hire a good photographer and three quarters of your work will already be done.

Rick Tharp, Tharp Did It, Los Gatos, California

ADDING COLOR TO BLACK-AND-WHITE PHOTOS

When appropriate, try printing black-and-white photographs as colored (PMS) halftones or colored duotones. If your job is a four-color process job, try specifying colored quadtones. This technique is useful for adding interest to your page layouts, especially when the photographs are not of the best quality or the project is only one or two colors. It breaks the monotony of seeing only black-and-white photos.

Maureen Erbe, Principal, Erbe Design, South Pasadena, California

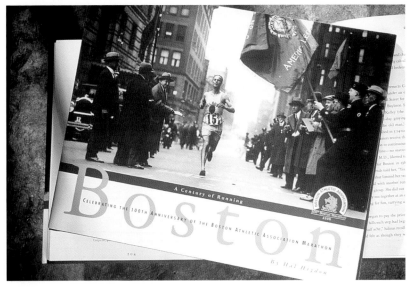

Adding color to black-and-white photos creates variety and interest in a layout that uses a lot of black-and-white images. These images from *Boston: A Century of Running* show how a touch of color works to enhance a black-and-white image and create a different mood.

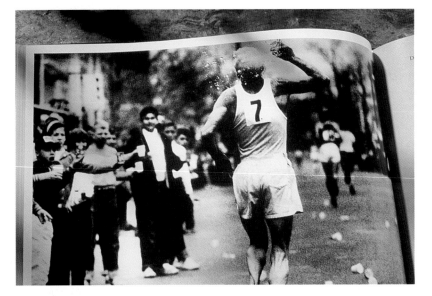

OPTIMIZING PHOTO CD FOR PRINT

Photo CD was created to view images on a video screen, and the scanning performed in Photo CD labs is optimized for this use, not for the printing process. Consequently, Photo CD images can exhibit characteristics unsuited for printing: low contrast, washed-out highlights and yellow casts, among others. These are problems color pre-press professionals solve routinely, but image correction takes time and requires specialized tools. Fortunately, these tools are now available, so publishers can get excellent quality from Photo CD images, and they can do so productively. Among the tools that can be used are Human Software's CD-Q and DPA Software's Intellihance.

Reprinted with permission from FYI: Photo CD, published by PrePress Solutions at the PrePRESS Main Street website (http://www.prepress.pps.com).

CHECK YOUR PHOTOGRAPHER'S RESOURCES

Cash flow is a problem in a profession where the outlay for equipment and supplies is large, especially when payment for services and out-of-pocket expenses can be withheld for upward of ninety days. In hiring a photographer, you want to be confident that he has adequate resources to complete the assignment. You don't want the photographer sweating about how the film is going to be paid for, distracting himself and compromising the job.

Stephen Hellerstein, photographer, New York City

STOCK PHOTOGRAPHY ON THE WEB

The World Wide Web's search capabilities are well suited for any kind of catalog browsing and shopping, and stock photography is no exception. At some of the larger stock photo sites, you can have access to thumbnails of thousands of images with no commitment to buy until you actually "check out" the images you've selected. This can be very handy when you're in a pinch or approaching a deadline.

LOW-RES VS. ROYALTY-FREE CDS

You must know what kind of licensing agreement you have before you use any of the images on a stock photo CD. Some stock photo agencies offer their catalogs on CD by presenting low-res versions of the photos which you can use for comps. However, you must order (and pay for) the high-res image or transparency if you plan to use it in print. Royalty-free image collections, on the other hand, are just that. Once you buy the disc, the images are yours to use without further charge.

USING DIGITIZED VIDEO FOOTAGE

Stills from archival video footage can make great photos and save money on the production end. For a calendar designed for Timex, we retrieved archival footage from old commercials. The video production studio pulled stills and saved them as TIFF (Tagged Image File Format) files. Using Adobe Photoshop, we enhanced and colorized the stills with the aid of various filters. This saved on the cost of photo retouching in the film separation stage.

Leslie Evans Design Associates, Portland, Maine

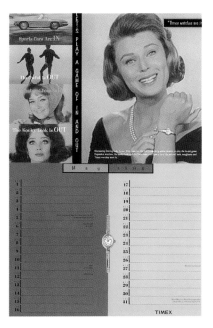

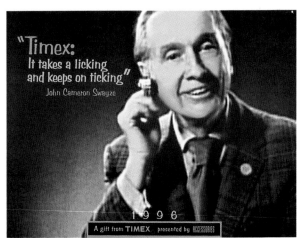

Stills from archival video footage make great photos and can save you money in the production process. A calendar for Timex designed by Leslie Evans Design Associates uses digitized video images.

WATCH YOUR FOLDERS WHEN COPYING PHOTO CD IMAGES

If the highest resolution (2,048 × 3,072) Photo CD images are taking a long time to open from the disc, try copying the file you want to your hard drive (it's faster than your CD-ROM drive). When copying Photo CD images, be sure to copy the Image Pac file from the "Images" folder (or directory) inside the Photo CD folder (or directory) and not the "Photos" folder. The "Photos" folder contains five additional folders—one for each resolution size of the Image Pac format—but the data inside those folders is what Kodak calls "entrance points." They are not image files and instead act like aliases (or what Microsoft Windows 95 calls "shortcuts"), linking these small image files to the actual Image Pac files stored in the "Images" folder. If you fail to copy the Image Pac file from the "Images" folder, the "entrance points" will not be linked to actual images.

Joe Farace, photographer/writer, Brighton, Colorado. Joe Farace is contributing editor to ComputerUSER *and* Photo-Electronic Imaging *magazines, technical editor of* Professional Photographer *magazine and author of several books on photography.*

ART DIRECTING PHOTO SHOOTS

The art director/designer can be an important buffer between the client and the photographer, acting as a confidence-builder and interpreter. Good planning and art direction are essential. However, the true brilliance is found through the process. Let the magic happen. Be open to what happens on the shoot. Let good people do good work—back off and be supportive. When it's right, say so. If it's not, let that be known. Lack of communication with a photographer leaves everyone on shaky ground. Once you have the required shot, if there's time, willingness and budget, play around. Who knows what could happen?

Stephen Hellerstein, photographer, New York City

PHOTOGRAPHING FLUORESCENT COLORS

Like fluorescent lighting, fluorescent colors are unpredictable. Some record faithfully, others erratically. It all depends on the dyes contained in the photographed image. Allow time and money in the budget for taking trial photographs and having working prints made of anything fluorescent. A good photographer will know how to compensate for some problems, or the printer may suggest using a matched fluorescent ink as a fifth ink or as a substitute for one of the process inks.

Condensed from the S.D. Warren book, A Team Approach to Photography for Reproduction.

Chapter Four

LOW-BUDGET SOLUTIONS

CLIP ART AND PHOTOCOPYING

If you think of clip art as existing art that you just plug into your layout, its uses might seem limited. But if you think of it as material that you can colorize, customize, posterize and utilize in any number of ways, its possibilities expand and become more interesting. Clip art expert Chuck Green, author of *Clip Art Crazy, Windows Edition*, offers several tips and tricks on selecting and making maximum use of clip art.

As for photocopying, a tip contributed by Westlake Village, California-based Talbot Design Group, says it all: "Your photocopier is a lonely little guy in the corner, full of untapped potential, just crying out to be used." See how some design firms have tapped this potential to get great backgrounds and borders for their designs.

MAKE AN ENVIRONMENTAL STATEMENT ON A TIGHT BUDGET

When working on an extremely tight budget (nonprofit style: $400 for a 1,500-piece run), we used a material we like to call "shoddy pad" for a booklet cover to make a visual yet environmental statement. Shoddy pad consists of unsold, shredded and rebonded Salvation Army and Goodwill clothing.

To keep the project within budget we begged printers to donate printing. The film house was not so willing. So we employed a few old-fashioned ideas. Manually typewritten text and captions were photo-copied, trimmed out and pasted onto actual page-size layouts of the lower-level surface. Cheapy quick prints to size were added to the top layer. Then we shot good old transparencies of the entire page and made the separations from there, creating an interesting effect and staying on budget.

Gregg Palazzolo, Palazzolo Design Studio, Ada, Michigan

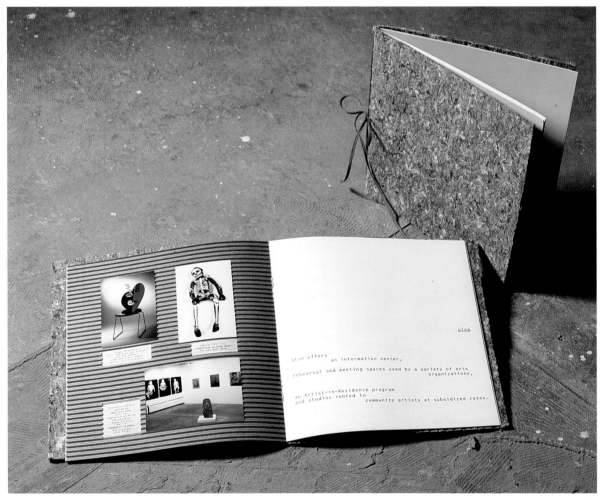

In a booklet designed for the Urban Institute on a low, low budget, Palazzolo Design relied on some old-fashioned tricks: photocopying and pasting onto page-size layouts, then shooting the page and doing sepa-rations from the transparency.

BAR CODES AS CLIP ART

Bar codes are essential for preprinted business reply envelopes. They speed return mail delivery and help the client qualify for postage discounts. Offering to provide correct bar codes is good customer service. To encourage people to use bar codes, the United States Postal Service will provide you with camera-ready positives of the bar codes you need for your designs. Check with your local post office about how to take advantage of this service. Once you have the bar codes, scan them in and use them as functional clip art.

Here are a few tips to give clip art a different look every time you use it.
- Experiment with different image-altering techniques available in illustration and graphic-manipulation software. Try even those filters and effects used for photographs. You'll be surprised how different clip art can look with one or two effects applied.
- Convert color line art to grayscale or black-and-white.
- Change the color of the background.

COLORING BLACK-AND-WHITE CLIP ART

To color black-and-white clip art, take the digital file you want to colorize and import it into a drawing program or page-layout program. Print it on plain white paper at 600dpi or higher resolution using either a laser printer or imagesetter. Then, using crayons or colored markers, color the image. Create a digital file of the colored image by scanning the sheet.

You can add color to black-and-white clip art manually and then scan the colored image.

Experiment with the technique and different coloring methods. You may find you have to enlarge the image before you print and color it in order to have ample room to add the color. Just remember to reduce the size of the image before you scan it.

You can also try using watercolors or other paints, but you may need to spray a clear sealant on the paper before you scan it.

GOOD ILLUSTRATION IS MORE THAN ORNAMENTATION

At a minimum, an image should grab attention and draw your reader into the message. At its best, it expresses your point better than words can. Rather than settle for an illustration of an object, search out an image that illustrates an idea or tells a story—it is far more interesting and effective.

Chuck Green, author of Clip Art Crazy, Windows Edition *(Peachpit Press), a collection of art on CD-ROM and a how-to guide for finding, choosing and using high-quality clip art.*

Choose quality clip art that illustrates an idea rather than clip art that just decorates.

NOT FOR RESALE

Most vendors allow you to use clip art in a design produced for a client for which you are paid. This includes use in logo design, stationery applications, brochures, newsletters, forms, ads, etc. Clip art may also be used for T-shirts, greeting cards, etc., when they are used as promotional items (such as items imprinted with a company name and logo to be given away to clients, customers or prospects). Use is generally prohibited if your client plans mass resale of the product you are designing. When in doubt, contact the vendor.

Brenda Lewis, Hexadecimal A Graphic Design/Ubangi Graphics, Detroit, Michigan

LOOK AT PARTS OF AN IMAGE

Make the most of your clip art packages by viewing images as individual parts. Select part of an image, cut it out and use it alone or in combination with other parts.

CREATE YOUR OWN CLIP ART

Clip art is really just a graphic file, so it's easy to create your own clip art collection. If you draw your own illustrations, you can scan and save them as graphic files. If you create illustrations digitally, you've already created a digital file. Make sure to keep the illustrations simple so you can reuse them in many different designs. Remember, too, that you can isolate part of a design and use it as clip art. You don't need to save the entire illustration.

CHANGING CLIP ART

Use your favorite image-editing software to change the appearance of clip art pieces. Try using the same special effects you'd use on photographs, such as embossing or three-dimensional effects.

Use your image-editing software to experiment with applying different effects to clip art.

CUT CLIP ART CLUTTER

Clip art is wonderful, abundant and fun to use. It can spice up fliers, newsletters and posters. Yet too many pictures on a page make it hard for the reader to concentrate on what the document says. Use clip art with moderation and with purpose. Make sure it supports your text or illustrates a point.

Jacci Howard Bear, JBdesigns, Austin, Texas. Excerpted from The INK Spot, *Vol. 3, Issue 1. The INK Spot On-line can also be found on the Web (http://members.aol.com/ink spotmag).*

YOU DON'T OWN YOUR CLIP ART

When you buy a collection of clip art or photographs, you buy the rights to use it, but you don't own the copyright. Be sure to read the legalese before you print your project in quantity. In some cases, you may be required to include a caption that credits the source.

There may be more subtle restrictions. A typical license agreement, for example, will allow you to print the clip art image on a T-shirt for your softball team, but it prohibits you from printing the same image on a shirt you plan to resell if the image is to be a substantial portion of what you are selling.

Contributed by Chuck Green, author of Clip Art Crazy, Windows Edition *(Peachpit Press), a collection of art on CD-ROM and a how-to guide for finding, choosing and using high-quality clip art.*

CLIP ART CHECKLIST

Once you've found a clip art illustration that looks good, ask yourself three questions:

Will it stand on its own?
Isolate the image from those around it. Lots of clip art grouped together on a page takes on a personality of its own. Cover the surrounding images to see if it works well independent of the others.

How well will it survive a size change?
An image that looks terrific at an inch across may not work as well at four or five inches across. And an image with lots of detail may look better large than small.

Does the shape fit my layout?
All the elements of the design should fit together like pieces of a puzzle. A long horizontal image may not work well on a short vertical brochure. Organic shapes may require white space you simply can't spare.

Chuck Green, author of Clip Art Crazy, Windows Edition *(Peachpit Press), a collection of art on CD-ROM and a how-to guide for finding, choosing and using high-quality clip art.*

Isolating a single image on a page will give you an idea of how it will stand on its own.

COMBINE CLIP ART FOR A NEW LOOK

To make clip art look new, try combining different pieces. Look for similar image styles in different collections. Experiment by putting different images side-by-side. Look for clip art clusters—several discrete images in one file. Open that file in your image-editing program and clip out one of the images to use in another collection or by itself.

CUSTOMIZING CLIP ART

You can customize clip art in a number of ways. If it was created in an EPS (Encapsulated PostScript) format or a paint program, you can alter it in a photo-manipulation program by using any of the many filters included in the program. Among the effects you can use are perspective, scaling, rotating, flipping, posterizing, colorizing, duo- or tritones, and various screening effects.

Tracy Burroughs, Little Men Studio, Redding, Connecticut

WORKING WITH A QUICK PRINT SHOP

Before you drop your job off to be photocopied, place your business card on the top sheet of the job and photocopy the two together. That way, if the job sheet and your job get separated, the print shop can call you for more information.

If your job is more than just a single sheet or requires some kind of finishing after it's copied, take a facsimile of the finished piece to show the shop how you want the collating, folding or other finishing done.

RECYCLED PAPER FOR PHOTOCOPYING

Recycled papers aren't always the smoothest or brightest papers available, making them less desirable than nonrecycled papers for photocopying. However, some recycled papers are acceptable for photocopying. Look for papers that have 25 percent or so post-consumer fiber content, a brightness of 84 or better and high opacity.

Little Men Studio offers its own small, stylized clip art collection.

GENERIC VS. STYLIZED

Clip art is marketed in two forms: the "mega" collections and the smaller, stylized collections. The former boast of having 40,000 to 100,000 pieces of clip art and usually sell from $19 to $39. These collections are created by the publisher who licenses art from other clip art vendors and utilizes public domain collections, which tend to be very generic looking. If this is the look you need, then these collections are a vast and economic resource.

The other kind of clip art collections are the small, stylized ones that sell from $19 to $129 and include anywhere from 30 to 300 pieces of art. For graphic artists who need spot illustrations with an edgy or artsy look, there are many collections from which to choose.

Tracy Burroughs, Little Men Studio, Redding, Connecticut

CREATING BORDERS WITH PHOTOCOPIED FABRIC

We wanted to create photograph borders for a brochure for Turtle Island, a Fijian resort. For an exotic effect, we photocopied pieces of Tapu cloth with traditional Fijian designs, which tend to be black and white with hard-edged graphics. Because you really live in the culture when you travel to this island, we wanted to incorporate some of the island's culture into the brochure.

KAISERDICKEN, Burlington, Vermont

KAISERDICKEN photocopied pieces of traditional fabric designs from Fiji and used them as borders for photographs and as bars to separate elements in the layout.

YOUR PHOTOCOPIER IS...

...a lonely little guy in the corner, full of untapped potential, just crying out to be used.

Talbot Design Group, Westlake Village, California

GETTING THE BEST OUTPUT FROM A PHOTOCOPIER

To get better looking output from a photocopier, use the whitest, slickest paper you can afford. Experiment with the new papers for laser printer output. If you're having the original reproduced at a quick print shop or copy shop, have the original copied on a few different papers before deciding which one to use.

If you print text onto a T-shirt transfer using conventional means, you'll probably end up with a mirror image of the text. To get it to read the right way, create it as a graphic that you can mirror.

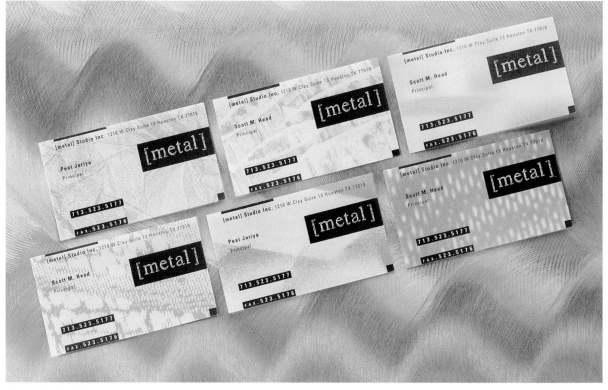

[metal] Studio created a variety of backgrounds for its business cards by photo-copying and scan-ning crumpled paper and various images. The cards come in eight different designs.

CREATING INTERESTING BUSINESS CARD BACKGROUNDS

In designing our business cards, we used a photocopier, scanner and Adobe Photoshop to create background textures and images from crumpled paper, pen-and-ink images of gears, and other patterns. We created eight different designs. Printed in metallic blue and black ink on translucent vellum, the cards reflect the company name.

Peat Jariya, [metal] Studio, Houston, Texas

CUSTOMIZING T-SHIRTS WITH A COLOR COPIER

You can create customized T-shirts and sweatshirts using a color copier. You'll need a photograph or other image to transfer, access to a color copier, heat-transfer paper, and a T-shirt or sweatshirt. Heat-transfer paper is a special paper designed to allow you to transfer any image onto fabric. It is sold under several brands and is available in paper-supply or craft-supply stores. Get the heat-transfer paper before you buy the garment; different brands work best with different types of fabric. You can transfer any image, but solid blocks of color work best. Avoid images with thin lines.

Once you have all the materials, follow these steps:

1. Load the heat-transfer paper into the copier, following the instructions that come with the paper. Photocopy the image onto the heat-transfer paper.

2. In order to transfer the image from the paper onto the garment, you need to apply heat. Follow the instructions for doing this: Some brands are designed for use with home irons, while others require more sophisticated garment presses.

3. After you've applied heat by ironing or pressing, let the paper cool to the touch and then gently pull the paper away from the garment.

PHOTOCOPYING FOR BACKGROUND EFFECTS

The photocopier offers endless possibilities if you're willing to experiment. Try some of these techniques to create editorial illustrations, spot illustrations, background imagery or texture in borders.

• Photocopy a flat object. Leaves, buttons, doilies, paper clips and coins all reproduce very nicely on a photocopier.

• Photocopy a texture. Crumpled paper; patterned or heavily textured fabric such as lace, burlap or terry cloth; gift wrap patterns and wood make great background textures when photocopied. "Degenerate" a texture by making copies of copies.

• Make a collage of photocopied images. Use a photocopier to reduce or enlarge photographs and clip art images. You can superimpose a head from one figure onto another, place people into settings of your choice and so on.

Reprinted with permission from Graphic Designer's Guide to Faster, Better, Easier Design and Production *by Poppy Evans, published by North Light Books.*

PRINTING TECHNIQUES

AND PAPER CHOICES

At what point do paper and printing considerations come into the design process? From the tricks and techniques described here, the message is clear: Take these essential parts of the process into account from the very beginning of a project. Printing options you might not have considered could lead to a change in size, paper stock or printing technique, leading to cost savings or more innovative designs. Don't let printing limit your choices—make it a part of them!

CHECKING FOR REGISTER

Comparison of an image in register and out of register.

When checking a press proof for elements that may be out of register, look around the sides of the sheet for the printer's registration marks. If those are in register, your images should be, too. If you see a fuzzy quality in the four-color, check the edge of each of your images or see if any of the graphic elements created out of process color are blurring. The color hanging out of alignment will immediately tell you which color is out of register and in which direction. Checking a couple of areas on the sheet will indicate whether it's an isolated or overall problem. Poor registration can change the actual (or perceived) color of an image or tint area.

In the images shown here, both sawtooth edges and color shift are noticeable in the image that is out of register (below left) when compared to the one that is in register (above left). The out-of-register match gold is visibly out of register in the second proof (at bottom of page).

Nanette Wright, Wright Communications Inc, New York City. Nanette Wright's guide to better printing, "On Press with Success," is available from Wright Communications, 67 Irving Place, New York, NY 10003; (212) 505-8200.

The match gold rule is out of register.

CREATE EXTRA-HEAVY ENVELOPES USING PAPER DUPLEXES

Want to create an extra-heavy envelope or packaging device? Try using duplexed papers. Buz Design created an envelope from a black and white duplex available from Strathmore Papers (Strathmore Grandee, White, 80# text and Strathmore Grandee, Black, 80# text). They printed the white side a match blue, and created a custom die made to size.

Williams & House and Pollard Design created a package for the Engraved Stationery Manufacturers Association from a custom duplex from two different colors of Strathmore Grandee Cover 80#. The extra-heavy package was then die cut and engraved. The die cut closure was applied with a grommeting machine. The piece was durable enough to endure the United States Postal System.

Williams & House, Avon, Connecticut

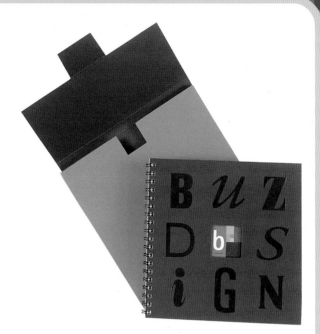

Envelope created by Buz Design from black and white duplex papers.

Image Value packaging for the Engraved Stationery Manufacturers Association, created by Williams & House and Pollard Design from a two-color custom duplex.

FAKING A FULL BLEED

If you want to fake the appearance of a full bleed on a letter-size sheet, extend the edges of the design so it's about one-half inch to one inch larger than a letter-size sheet. Have the page output on a tabloid printer and trim it back down to letter size.

COLOR PRINTING WITH BLACK INK

The cheapest and easiest way to get color printing is to use black ink on colored paper. Getting the best-looking printed piece takes some experimentation. A rule of thumb is to use light-colored paper for the best contrast.

Experiment before you design by asking your printer for some samples of colored paper and spend some time sketching on the paper with black marker to get an idea of what the printed piece would look like. Another way to get an idea of what your design will look like when printed is to buy colored laser papers that look like the stock you have and print your design on them.

TIME OUT

If you download a file to your PostScript laser printer or imagesetter only to find that nothing prints, or you get a blank sheet of paper, try increasing the Jobtimeout setting. The Jobtimeout setting, which every PostScript printer or imagesetter has, is a PostScript language setting that tells the printer how many seconds it should work on a job before giving up. The time may be too short if the printer has to do many complex calculations. To increase the Jobtimeout setting, first consult the printer's manual. The printer management utility shipped with many new printers has a quick and easy way of increasing the setting. Double or triple the setting and then download the file again.

TAP YOUR PAPER MERCHANT FOR IDEAS

Develop a relationship with your local paper merchants—they are excellent sources of information and services. Most merchants will help create paper dummies for your design concepts or come up with new ideas for binding, folding and packaging. In return, all they want you to do is ask your printer to buy their paper once the job is live.

Contributed by Williams & House, Avon, Connecticut

LAMINATE IT

To add stiffness and gloss to a printed sheet, have it laminated. Lamination also helps protect the sheet from the elements. You can have the sheet laminated on one or both sides with either thick or thin laminates. Check with a local printer or finishing house to see what lamination options they offer and how much they charge.

MULTIPLE MEDIA FOR A COLLEGE-AGE AUDIENCE

Projects directed to a college-age audience are always a challenge: A designer must balance the environmental awareness of today's youth with the need to attract their attention. The brochure we designed to promote fraternity and sorority life at Drake University seemed tailor-made for recycled and industrial papers.

Using the theme, "Be a Part of It," we incorporated chipboard, manila and Curtis Retreeve into the mailer. The double-ply chipboard cover—in addition to being a good environmental choice—was convincing as a die-cut puzzle. Affixed to the chipboard are imprinted "parts," including hammered aluminum, label stock and manila tags. Each bears a word from the brochure's title.

Inside the piece, a variety of printing and finishing techniques are used for graphics and copy, including thermography, embossing, die cutting and offset printing. Hand-applied glassine envelopes contain additional information. The brochure is bound with wire-o binding and an aluminum ring.

Sheree Clark, Sayles Graphic Design, Des Moines, Iowa

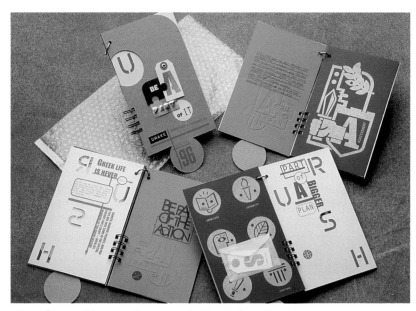

"Be a Part of It" brochure for Drake University by Sayles Graphic Design.

TALKING TO YOUR PRINTER ABOUT COST SAVINGS

Make sure your printer knows you want to save money without sacrificing quality. He may come up with unexpected innovations. For example, he may point out that by making a brochure slightly smaller, he can fit in on a press that costs less to run—and save you money in printing costs.

PRINTER TYPES FOR GRAPHIC ARTS SHOPS

For graphic arts businesses, the three most interesting printer technologies are as follows:

• Solid ink, which offers great-looking output on a variety of paper types and sizes.

• Dye sublimation, which offers good photo-realistic output at a lower cost than other alternatives.

• Color laser printers, which offer excellent output and fast print speeds. The size of this type of printer, as well as the cost and complexity, also has to be considered.

Reprinted from Simply Brilliant, A Guide to Color Printers for Graphic Arts, *from Tektronix, Inc.*

ENGRAVING TIP #1: PRINT COLORS ON DARK STOCK

Engraving is a sometimes overlooked design option, because many designers perceive it as dated or too expensive. But the options available at your engraver aren't available anywhere else, and they can take your designs to a whole new level.

For example, have you ever wanted to spec a dark stock, but didn't because you were afraid of paper show-through? Engraving inks are so opaque, you can actually engrave very light match colors—or even white—on the darkest papers. Because they're thicker and more opaque than other inks, you can also engrave very fine type on textured papers. Los Angeles-based Baker Design used this technique on its 1996 self-promotional calendar.

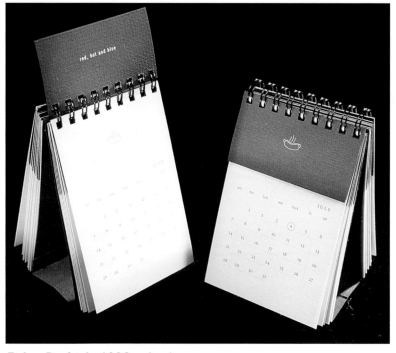

Baker Design's 1996 calendar uses very fine engraved type on textured papers.

Williams & House, Avon, Connecticut

ENGRAVING TIP #2:
COLORS AND METALLICS

Engraving inks come in a nearly limitless array of colors. Your engraver can match colors in any numbered matching system, or even a piece of fabric or paper. Metallic engraving inks are made up of tiny bits of metal, which reflect light differently than pigment-based engraving inks. (This can make type difficult to read if it's too small.) Try making the type size or images heavier, or burnish the inks by hitting the image with an inkless die in a second pass. This creates a matte metallic finish that no lithographic process can match.

Don't be afraid to specify engraving for corporate identity jobs: Engraving is completely compatible with laser printers, and is often more affordable than you think (especially for shorter runs). A book designed for the Engraved Stationery Manufacturers Association shows the use of colored engraving inks.

Williams & House, Avon, Connecticut

Engraved Stationery Manufacturers Association engraving education book.

FLEXIBILITY CAN SAVE MONEY

Negotiate discounts for a flexible print schedule. If you can schedule your job for off-peak hours or days, you might be able to get a reduced price.

DEALING WITH INK COVERAGE IN HIFI PRINTING

Consider using a waterless press if you are doing HiFi printing (printing with six or more colors) as a way to deal with the substantial increase in the amount of liquid that is laid on the paper. Whether you go waterless or not, a heavy book weight or cover stock is better suited to handle the increase in ink coverage and help prevent warping and stretching that can cause out-of-register colors.

Kirk Lyford, Vivid Details, Ojai, California. Reprinted with permission from the Vivid Details website (http://www.vividdetails.com).

MATCHING CROSSOVERS

It's important to let your printer know right from the beginning about any images that cross over the gutter from one page to another. Because each half of the image may be printing in different areas and quite possibly different sides of your press sheet, it may be possible to plan an imposition that gives you better color control, making it easier to match your crossovers. If possible, request to print the most complex side of the sheet (the side with the least color control) first because matching the crossover on the second side should be easier.

Nanette Wright, Wright Communications, Inc., New York City. Nanette Wright's guide to better printing, "On Press With Success," is available from Wright Communications, 67 Irving Place, New York, NY 10003; (212) 505-8200.

INNOVATE AND LAMINATE

When your client needs to keep their name in front of their clients and they want a piece to have an indefinite shelf life, try this innovative technique. (Your printer will love you for it!)

1. Starting with your favorite text or cover stock, designate an area or areas to lay down five to ten hits (we used seven) of opaque white ink on top of the stock.

2. Print your process separation over top of the ink field.

3. Dry and apply spot aqueous coating over the process separation, including any blind or covering graphics.

4. Laminate the text or cover stock to a heavy chipboard or other material and trim out to create a visually intriguing yet durable cover.

The phone booklet we designed for National Correct Color shows the results you can get with this technique.

Gregg Palazzolo, Palazzolo Design Studio, Ada, Michigan

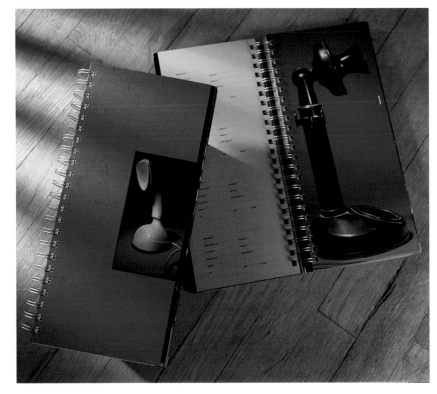

Phone booklet for National Correct Color designed by Palazzolo Design Studio.

FOLDING TO REDUCE PRINTING COSTS

To reduce printing costs on a small booklet like the one the WPS Design Group designed for Martex, design French-folded pages so that you only have to print on one side. Then bind it with a unique technique: a Japanese stitched binding, perfect binding, eyeletting or just a simple wraparound cover and a ribbon.

Williams & House, Avon, Connecticut

Martex booklet from WPS Design Group (in-house creative service at West Point Stevens, Inc.).

NEGOTIATING THE BEST PRINTING METHOD FOR YOUR CLIENTS

When do you talk to your printer (or service bureau) about a job? When your project is ready for printing? Halfway through the project? Ideally, you should talk with your printer as soon as you take on a new project—perhaps even before you accept it from your client. If you plan to deliver camera-ready art, consult with your printer before you open your drawing or layout program and before scanning any artwork or photos. You will get better results, save time and possibly save money.

Jacci Howard Bear, JBdesigns, Austin, Texas. Excerpted from The INK Spot, *Vol. 3, Issue 1. The INK Spot On-line can also be found on the World Wide Web (http://mem bers.aol.com/inkspotmag).*

USE DULL VARNISH FOR CONTRAST

Using a dull varnish on a gloss sheet will produce more surface contrast than using a gloss varnish on a dull stock when you varnish in-line. For even greater contrast, varnish off-line as a separate run so no varnish is absorbed into the paper. Dull varnish scratches more easily than gloss varnish does, however, so keep the end use of your piece in mind when deciding which path to take.

Reprinted with permission from Step-By-Step Graphics, *November/ December 1996.*

HIFI PRINTING SPECIFICATIONS

HiFi color printing (a printing process that uses six to eight inks) is intended for high-end publishing projects. That, coupled with the inherent differences of HiFi color printing, limits your choice of suppliers, equipment, line screen and content. Since HiFi's main purpose is to faithfully reproduce extremely vibrant, colorful images, it's obvious that a high-quality, bright white coated stock will go a long way to enhance the final appearance. Aesthetics is not the only criterion for selecting a coated stock, however. A non-absorbent paper can also help control dot gain, a critical ingredient in achieving color saturation.

A sheetfed press can better accommodate the increased demands and precision that HiFi printing requires than a web press.

Kirk Lyford, Vivid Details, Ojai, California. Reprinted with permission from the Vivid Details website (http://www. vividdetails.com).

USING LABEL STOCK CREATIVELY

To create the effect of a custom printed box for our 1994 holiday greeting package, we designed and printed a custom label to coordinate with the off-the-shelf white box. Once applied, the self-adhesive label stock created a package that appeared to be custom printed—at a fraction of the cost.

Williams & House, Avon, Connecticut

PRINTING ON PREPRINTED PAPER

If you use preprinted papers and card stock frequently, you know that designing the finished piece can be tricky. No matter how well you set up the guide in your layout program, you always seem to waste a few pages getting it right. To avoid this, print your design on overhead transparency material first. Lay the printed transparency over a sheet of the preprinted paper to check the position of your text and graphics.

Williams & House gift box. Using self-adhesive label stock over an off-the-shelf white box gives the look of a custom-printed box.

JUICY COVER

If you want a nice, thick, juicy cover for a book or multipage document and the budget is tying you down a bit, we propose a technique that served us well in a day planner we designed for Modern Imaging.

1. Core and double over or reverse-fold the front and back covers with a dense, coffee-with-cream toned chipboard (10 point or better board) or any other cool, industrialesque packaging material.

2. Bind the open ends of the covers, to the gutter side, with spiral or double wire-o. Or use a copper-side (also known as "top") stitch.

3. Finish it off with a tip-on or tip-in applying label or stamping.

Gregg Palazzolo, Palazzolo Design Studio, Ada, Michigan

Modern Imaging day planner from Palazzolo Design Studio.

DELIVER QUALITY, BE REMEMBERED

Working with your client and printer from the beginning stages of a project will allow you to work out the most cost-effective production and printing method to ensure the publication envisioned by you and your client is how the final printed piece will actually look. Your client will remember you as the designer who delivers top quality work—start to finish. Your printer will remember you as the professional who not only knows how to design good newsletters, brochures or logos—but who knows how and when to talk to a printer.

Jacci Howard Bear, JBdesigns, Austin, Texas. Excerpted from The INK Spot, Vol. 3, Issue 1. The INK Spot On-line can be found on the World Wide Web (http://members. aol.com/inkspotmag).

USE END-LOT MATERIALS TO SAVE COST

Ask your printer about special pricing if you use "end lot" materials. If the printer uses a regular quantity of such materials for regular, larger customers, you may be able to use the left-over materials for your designs.

CHECKING FOR DOT GAIN

Dot gain occurs when a dot is printing much larger than intended or specified. To identify dot gain, check the color bar percentages and/or compare the dots on your proof with the dots on the printed sheet under a loupe. Printers should adjust for dot gain that normally occurs on uncoated papers. Different papers can add anywhere from 10 to 30 percent dot gain depending on surface, finish and overall print quality. A comparison of the same image printed on coated paper (left) and uncoated paper (right) shows the differences in dot gain between the two. Coated paper gives a sharper image, while uncoated paper produces a softer look.

Nanette Wright, Wright Communications Inc, New York City. Nanette Wright's guide to better printing, "On Press With Success," is available from Wright Communications, 67 Irving Place, New York, NY 10003; (212) 505-8200.

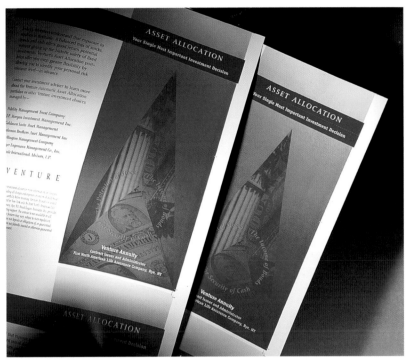

A comparison of the same image printed on coated and uncoated paper shows the difference in dot gain between the two.

ADD FLUORESCENT INK WHEN PRINTING ON UNCOATED PAPER

Mixing a little fluorescent ink with standard inks—adding 50 percent fluorescent to yellow and magenta, for example—can brighten an image that will be printed on uncoated paper.

KAISERDICKEN, Burlington, Vermont

DISCOUNT FOR NOT CHANGING INKS

Inquire about discounts for using the same inks used in a large print job. The printer saves money by not having to change inks from one job to the next.

COLOR PRINTING WITH ONE INK

You can get the look of color printing by printing a monochrome image or illustration on colored paper. You use one color of ink (not black). Try using ink that is the same color and a few shades darker than the paper. Getting just the look you want can be tricky, so ask your printer for advice.

BETTER BINDERS

For the next binder job you get, try this: When speaking with the binder manufacturer, find out what substratum they plan to use. It could be chip or rag board or something synthetic. If the texture or color is cool, start out by using a clear or transparent wrapping. Next, ask to have one or both sides screenprinted. Design as desired and watch the reactions to the final piece. We customized a binder for Turnstone, a steel case company, in this way.

Gregg Palazzolo, Palazzolo Design Studio, Ada, Michigan

Turnstone binder from Palazzolo Design.

SCHEDULING YOUR JOB: GET YOUR PRINTER'S FULL ATTENTION

Talk to your printer about scheduling to avoid his peak load days. Even if there's no price break, your job will get better treatment if the printer gives it his full attention.

Peter Dyson, Seybold Publications, Media, Pennsylvania

PRINTING ON BRIGHT PAPER

Colorful paper can make your printed materials stand out from the crowd, but printing on colored stock can make even opaque inks appear dull and muddy. If you lay opaque white ink under bright inks, however, the lively colors will retain their vibrancy, no matter what stock you choose.

Reprinted with permission from Step-By-Step Graphics, *November/December 1996.*

INK FOR LETTERHEADS

If your letterhead design contains printed ink coverage on the letter area, specify laser-compatible inks or make sure your letterhead sits for at least three months before running it through a laser printer to ensure you don't damage your printer.

Cathy Cotter, Cotter Visual Communications, Landenberg, Pennsylvania

METAL VS. DISPOSABLE PLATES

Some quick-print shops use only disposable plates. On a large run, these plates can stretch and spot color registration can shift noticeably. Metal plates can cost extra and may be the only option with some printers. Some shops will shoot the negative for plates from your mechanical. Others can take your computer file in place of a "paper" mechanical.

Jacci Howard Bear, JBdesigns, Austin, Texas. Excerpted from The INK Spot, *Vol. 3, Issue 1; The INK Spot On-line can be found on the World Wide Web (http://members. aol.com/inkspotmag).*

Chapter Six

COMPUTER GRAPHICS

COOL EFFECTS, SPACE-SAVING TRICKS AND FILE MANAGEMENT

The computer has become omnipresent in design offices. Some designers have delved deep into the mysteries of graphics programs and cross-platform issues. The less hardy of soul work with computers on a daily basis but learn only what they need to know to do the job. This chapter has tips and tricks for both kinds: advanced drawing, image-editing and graphics tricks; tips on handling numerous file-format issues; and some tips for dealing with the ever-more-common situation of exchanging and converting files between Macintoshes and PCs.

POSTERIZING IN PHOTOSHOP

In designing the Simple Amusements book for Georgia Pacific, we created a dramatic posterized effect with the image of a top by using the following steps:

1. Repeating the object a number of times
2. Colorizing the image in Hue/Saturation
3. Posterizing it
4. Repeating the graphic in the page layout

The four-color process posterization was printed with a background of one match color.

Leslie Evans Design Associates, Portland, Maine

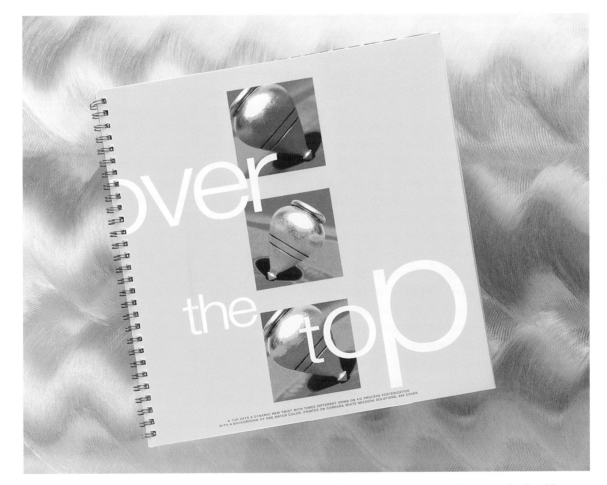

In the Simple Amusements book Leslie Evans Design Associates designed for Georgia Pacific, the image of the top was repeated, colorized and posterized in Adobe Photoshop.

TURNING LAYERS OFF FOR PRINTING IN ADOBE ILLUSTRATOR

When using Adobe Illustrator's Layers feature, you can turn printing on and off for any given layer. It is sometimes helpful to turn a layer's printing off because it has some very complicated art or high-res images and you just need a quick proof of the rest of the file. To keep track of layers whose printing is off, type "OFF" into the layer's name. When you turn the layer's printing back on, remove the word "OFF" from the layer's name. (Making a layer not "show" does not turn its printing off, it only hides it on the screen.)

Jym Warhol, MetaDesign, San Francisco

USE LAYERS FOR MINOR CHANGES IN ILLUSTRATOR

If you are working in Adobe Illustrator and have a complex drawing that needs minor variations such as a color change on a logo, instead of making multiple copies of the artwork for each variation, copy the logo onto another layer. (Make a new layer by option-dragging the little square on the right side of the layer name into the new layer. This will copy it to exactly the same position.) Then turn off the printing of layers for the variations you don't want to print. Now you can change other parts of the drawing and apply them to all your variations.

Jym Warhol, MetaDesign, San Francisco

IMAGE FILE TYPES TO AVOID AND WHEN TO AVOID THEM

Avoid saving designs in application-specific files, particularly if someone else is going to use the file later. If they don't have the right software or the right version, they won't be able to open the file.

Avoid using EPS (Encapsulated PostScript) files when passing a design on to someone else. Some images and page layout programs cannot read EPS files created in other applications. Use TIFF, PCX or PICT instead. When in doubt, ask what file formats are acceptable.

WHERE TO MAKE CHANGES

Make all changes, including cropping, rotating and scaling, to each graphic using an image-editing program before you import it into your page layout program. Doing so makes files print more quickly.

Taken from material provided by the Scitex Graphic Arts Users Association.

COMPUTER COLLAGING TRICKS AND TOOLS

Creating a collaged graph about recycling involved a variety of computer graphics tricks and tools. I began by scanning empty containers directly on a flatbed scanner. A lot of color correcting, retouching and contrast adjustment was necessary to enhance the scans, which were rather crude.

After creating the collage of the garbage, I created the top and right sides and gave depth to the image by selecting strips on the tops and right sides, duplicating them, distorting them with the Adobe Photoshop Effects functions and darkening them with the "light" and "dark" function. This resulted in the rectangular box effect. I ghosted the strip at the top slightly to accommodate the type I was going to add later.

The globe in the image is a piece of clip art that I colored. I created the look of a sliced egg in Photoshop. The numbers in the globe were created in Adobe Illustrator and filled with gradations using the gradations palette. I distorted them so they would conform to the slice of the earth to which they belonged. Finally, I imported the Photoshop art and Illustrator numbers into QuarkXPress and added the type.

Tracy Burroughs, Little Men Studio, Redding, Connecticut

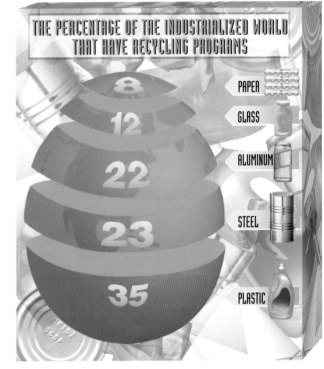

A graph about recycling worldwide was created using a background of scanned containers which was then collaged in Photoshop, with various effects applied. Illustrator and Quark were also used to create the final design.

SAVE LOGOS AS GRAPHICS

When you create a logo using text and graphics, save the entire object as a graphic (EPS, TIFF, PCX). That way, you don't have to worry about the logo looking dramatically different when imaged. The text in the logo will not be interpreted as text by the output device.

SAVE LAYERS

If you are working in Adobe Photoshop or another program that uses layers, save the layered version of your work. You never know when you will need to isolate an element from an old illustration or make an alteration.

Tracy Burroughs, Little Men Studio, Redding, Connecticut

LINKING IN ADOBE PAGEMAKER

Using the "include placed images" command in Adobe PageMaker has no effect on linking. This option allows for a better laser print image (while making files huge). You still need to send all original graphics along for modification or output.

Gilbert Cosme, Jr., Typography Unlimited, Phoenix, Arizona

CREATING SLIDES DIGITALLY

When you create slides digitally, the page size must be set to a ratio of 2" × 3". A 35mm slide frame has a 2" × 3" ratio. If your software program has a 35mm setting, use it. If it doesn't, a custom page size of 6" × 9" or 8" × 12" (landscape) will suffice.

Richard Banse, Jr., Attention Graphic Enterprises, Norristown, Pennsylvania

READING A PC DISK ON A MACINTOSH

Recognizing that the computing world is not entirely populated by Macintosh users, Apple Computer created PC Exchange, a System 7 control panel. If PC Exchange is installed on your Macintosh, you can read a PC disk as well as you can a Macintosh disk. This does not mean, however, that you can read a Windows-only file format such as Windows Bitmap (BMP) or Windows Metafile. Try cross-platform file types such as TIFF, PICT or PCX.

KEEP WORKING FILES SEPARATE FROM APPLICATION FILES

Keep your working files (designs, templates, graphics) in directories separate from your applications (page layout, drawing programs, etc.). Keeping your working directories separate makes for easier, more efficient backups. For example, you may wish to back up your working files daily and your application files weekly or monthly.

Keeping files separate also means you can safely run automatic upgrade utilities or delete entire directories when upgrading or reinstalling application software.

POSTERIZE A NEGATIVE IMAGE

1. Take an ordinary object and isolate it in Adobe Photoshop.
2. Invert the image, making it a negative.
3. Posterize the image until the desired contrast is achieved.

Leslie Evans Design Associates, Portland, Maine

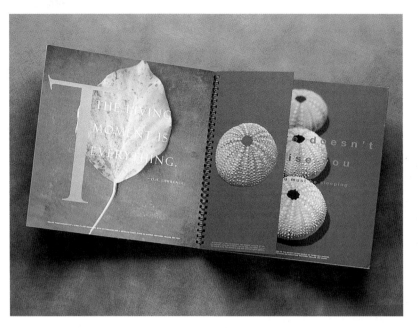

Posterized image of a sea urchin from the Simple Nature brochure for Georgia Pacific by Leslie Evans Design Associates.

MAKING MEASUREMENTS IN PHOTOSHOP

To make measurements in Adobe Photoshop, use the line tool with a setting of zero and get your readings from the "info" window. You can also measure angles with this technique.

Jym Warhol, MetaDesign, San Francisco

CREATING A RELIEF EFFECT

If your image-editing or retouching program accommodates filters, try applying an embossing filter to a gray-scale image to create a relief effect.

CRISPER TYPE IN GRAPHICS

Add type to an illustration or graphic piece in QuarkXPress or a PostScript-based illustration program like Adobe Illustrator because it will come out crisper than creating type in a bit map manipulation program like Adobe Photoshop.

Tracy Burroughs, Little Men Studio, Redding, Connecticut

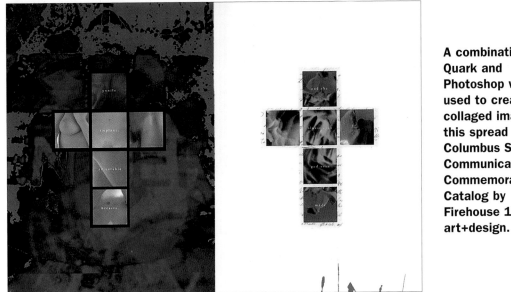

A combination of Quark and Photoshop was used to create the collaged images on this spread from the Columbus Society of Communicating Arts Commemorative Catalog by Firehouse 101 art+design.

COLLAGING IN PHOTOSHOP AND QUARK

In the creation of the graphics for Columbus Society of Communicating Arts Commemorative Catalog, we worked with a lot of found art and used a combination of Adobe Photoshop and QuarkXPress to collage and compose images. In the spread shown above, the background image on the left is a collage created in Photoshop and saved as a TIFF file, with color fixed in Quark. The cross-es were created in Quark using positive images on the left and negative images on the right. The letter behind the cross on the right was created in Photoshop using an old letter cut out in a cross shape and then feathered on the edge.

Kirk Richard Smith, Firehouse 101 art+design, Columbus, Ohio

SILHOUETTES IN PHOTOSHOP

If you're working in Adobe Photoshop, create silhouettes with the path tool. Use this path as a clipping path, and save the file in EPS.

Gilbert Cosme, Jr., Typography Unlimited, Phoenix, Arizona

BACK UP!

Back up all your files every day. No one in the graphic design or desktop publishing business can afford to lose customer's files, or, for that matter, their own billing records and other in-house files. The money you spend on a backup system will be paid by the time saved in not having to redo work you'll only get paid for once.

Kate Binder, Ursa Editorial Design, Rowley, Massachusetts

WORKING WITH A CLIENT'S FILE

Working with graphic and desktop publishing files you didn't create can be troublesome, especially when the production "buck" stops at your desk. You can make this task a little easier by following some standard procedures. Before you ever open the file, find out what platform and program the file was created in. Cross-platform editing can be a nightmare. For example, you may not be able to open a Macintosh file on a PC, even if you are using the same application. Whenever possible, use the same platform and version of the software to open and print a file. If you can't, allocate extra time to solve any problems you may encounter.

STOP JUGGLING CD-ROM AND PHOTO CD DISCS

Do you find yourself juggling several Photo CD discs, special-effect discs and texture discs when trying to apply an effect to a Photo CD image? This can be a problem: Working with several discs at once slows the creative process and some programs demand that the original disc be in the CD-ROM drive. To get around this problem, you have two options: Copy the Photo CD files to your hard drive or install a CD-ROM changer.

Joe Farace, photographer/writer, Brighton, Colorado. Farace is contributing editor to ComputerUSER *and* Photo-Electronic Imaging *magazines, technical editor of* Professional Photographer *magazine and author of several books on photography.*

BACK UP BEFORE YOU OPEN

When someone gives you a file, copy the file before you even try to open it. Use your copy as the working version, and file the original away. With some applications, just opening a file irretrievably changes it.

SAVING IN A PAGE LAYOUT PROGRAM SAVES MEMORY

If you put scanned elements and type elements together in a page-layout program like QuarkXPress rather than in an illustration program, the final document will take up a lot less memory.

Tracy Burroughs, Little Men Studio, Redding, Connecticut

APPLYING A TEXTURE TO TEXT

You can add interest to a bit of text by applying a texture to it. This effect is usually added to stand-alone or head-line text. The same technique can also be used to add a textured look to any object. You can create this effect with any program that allows you to change fills, and layer and edit objects. The easiest way to add texture to text is to fill the letter with a texture fill. If the program comes with textured fills, it is a simple matter to substitute the texture for the default fill (usually black). If you like this effect and want to use specific textures from other sources, look for a program that will let you import textures and use them to fill objects.

You can use fills to apply texture to type as you would to an object.

If your software does not directly support textured fills, you can use the following technique to create a fill:

1. Import the texture you want to use in the text as a graphic.

2. Make the fill of the text you are using transparent. Make sure to leave a thin black line as the outline for the text.

3. Place the text on top of the texture. Layer the two so that the text is on the top layer. You should now see the texture "through" the text.

4. Using the cutting, erasing and other image-editing tools in the program, slice the text away from the background. Enlarge the view so you can see small portions of the image. Go slowly around the outside of the text, erasing the unneeded portions of the background. Do the same for any other portions of the letter.

5. Save the results as a graphic.

Note: Different drawing and illustration programs allow you to achieve the same effect using different methods. Check out the documentation and follow the recommended method for applying a texture before you try this general method.

ONCE IMPORTED, DON'T RENAME EPS FILES

Page-layout programs treat EPS files as electronic pick-ups. After placing EPS files in a page-layout document, don't rename the EPS files. The EPS file name is the link between the page-layout program and the EPS file.

Based on material submitted by the Scitex Graphic Arts Users Association.

CHECK FILES FOR IMAGES AND FONTS

When you receive a file from a client, illustrator, freelancer or anyone else, make sure you have all the images and fonts used in the file. Check the contents of the file folder. Don't rely on what you see on screen. This is especially important with scanned images. Some programs don't alert you that the high-resolution version of the image is missing and will cheerfully print the file using the low-res image you see on screen.

BEWARE OF EMBEDDED GRAPHICS

Embedding graphics in a page layout file means you don't have to worry about transporting the graphic files along with the page files. However, embedding graphics might not save time in the end. The page-layout files will be much larger and are more likely to become corrupted. Any changes to graphics will have to be reimported. Subsequent users of the files, such as companies charged with converting them to HTML (Hypertext Markup Language), will need the original.

Kate Binder, Ursa Editorial Design, Rowley, Massachusetts

MAKE YOUR SIGNATURE A GRAPHIC

If you're creating sales letters, form letters or any type of printed correspondence, it's easy to add your signature without spending hours signing your name to each letter. Once you've created a graphic image of your signature, you can use it in many different ways. Some e-mail programs even allow you to import a graphic, so you could sign your e-mail messages!

Simply sign your name in several different sizes, leaving plenty of space around each signature. Scan each signature individually and save it in several different file formats. Make an EPS file if you can. Consider using a password to protect the files against unauthorized use. You can use the resulting graphic in any file that accepts pictures. You may need to experiment to find the file format most readily accepted by your word processing or page-layout program.

MULTIMEDIA DESIGN

AND TECHNICAL TRICKS

While multimedia design employs many of the principles of information organization with which graphic designers are very familiar, the technical areas of compression, scripting and programming are new to most designers. In this chapter, several design firms who have taken the lead in this field share their expertise on designing interactive presentations for the World Wide Web, CD-ROM and floppy disk.

BREAD CRUMB TRAIL NAVIGATION

Perhaps the most significant issue that distinguishes print design from electronic design is navigation. We've found that the concept of a "bread crumb trail" helps interactive users find their way. Unlike Hansel and Gretel in the forest, designers can leave clues that not only mark the path taken, but also show where other paths might lead.

There are many ways to apply this principle, some more efficient than others. The bread crumb trail for the UniDial prototype site consists of very small (1.7k) animated dotted lines related to the site concept "connections." The animated lines indicate which item on a list of navigation options is the active selection. The vertical column of animated dots on the home page set up the color palette and concept, the short horizontal lines indicate the active selection from a list, while a horizontal-vertical combination calls attention to a new selection and its options.

We have used this concept on many of our sites (for example, http://www.cinbelltel.com and http://www.nationalgeographic.com/modules/grandcanyon/index.html).

Mike Zender, Zender & Associates, Cincinnati, Ohio

In the first four screens of a prototype site for UniDial (top and left), each animated button in the vertical row on the home page is a different color, setting up the color palette and concept for the site. The bright green animation shows "Company" is the current selection (left). The horizontal/vertical animation (below) shows "Management" is selected and points to options below. These animated lines and dots create a "bread crumb trail" showing the paths the user has taken and where other paths lead.

PRESENTING WEB DESIGN SERVICES

How do you show potential clients your web design work? We print out color lasers of sample screen shots and mount them on large boards. We also show our schematic process to accompany each site and board. We sometimes bring a laptop to a presentation and show files on screen (not hooked up to the Internet). This allows us to control the presentation.

Hal Apple, Hal Apple Design, San Francisco

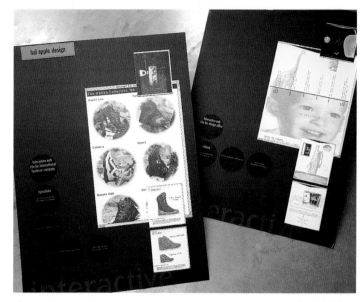

Presenting web design services on large boards is less threatening for clients and gives you more control over the presentation than trying to do a "live" web presentation.

VIEWING OPTIONS

Rather than putting them at the very beginning, put elaborate graphics and long videos further along in the presentation. Give the user the option of skipping these elements by presenting a text-only version of the page or presentation. Offering a text-only version is especially important if you are designing a web presentation and don't know how well the user's browser handles graphics. If you can't offer a text-only version, consider telling how large the files are before the user attempts to download or view them.

NO WAITING

When developing any kind of multimedia presentation, make something happen immediately after the user has started the presentation. Make it simple so the user doesn't have to wait minutes, or even seconds, to see a graphic or video. The idea is to get their attention quickly.

WYSIWYG YOUR TEXT EDITOR

Use WYSIWYG (What You See Is What You Get) editors to save time, and tweak your pages with a text editor. WYSIWYG editors like Claris Homepage and Adobe PageMill allow you to quickly place graphics and text on a page and output code that is consistently formatted. A page that has gone through multiple revisions, often by different people, can quickly become very hard to read. I often open pages in a WYSIWYG editor and resave them just to have the code reformatted.

Be warned, however, that some of these formatting conventions can change the appearance of your page.

Two common examples are the placement of <P> and </TD> tags in a document by Claris Homepage. Claris Homepage inserts a return and places </TD> tags on a new line in table layouts. This results in a tiny buffer between table cells that you may not notice unless you are trying to butt graphics in two adjacent cells together. Similarly, the spacing is different among images separated by a <P> tag, depending on whether the tag is placed at the beginning or end of a line.

Mike Zender, Zender & Associates, Cincinnati, Ohio

SCREEN ORGANIZATION

Organization of space is just as important in screen design as it is in page design–perhaps even more important. Usually you'll want to set up a basic structure for the screen and stick to it. Keep similar elements, such as navigation buttons, text and art, in a certain set position. Otherwise, the viewer's eye has to jump around the screen, which can be confusing.

Reprinted from The Basics of Color Design: Guidelines for Creating Color Documents, *a pamphlet published by Apple Computer, Inc.*

COMPRESS BEFORE YOU UPLOAD

Before you upload a QuickTime movie to the World Wide Web, compress it. Use multimedia editing software (such as Adobe Premiere) and follow these guidelines:

• Choose a 240 × 180 ppi or smaller window size. The smaller the window, the faster the download will be.
• Use Cinepak compression.
• If your source footage is noisy, use the program's noise reduction feature to add a small amount of Blur or Gaussian Blur. This will improve the compression.
• You may need to try different data rate settings because the Cinepak codec doesn't yield exactly the rate specified in the software. The true data rate is always lower. Start with 150KB per second for 240 × 180 ppi movies.

Condensed from material presented on the Adobe website (www.adobe.com).

SPACE-SAVING TRICKS: REDUCE, REUSE, RECYCLE

AV Media created an interactive self-promotion piece to fit on a 1.4MB floppy disk. Doing so required numerous tricks for keeping file sizes and processor-intensive applications to a minimum. We took the general approach of using as much scripting as possible while limiting heavy objects such as images and sound. Storage real-estate was budgeted carefully from the start, with an emphasis on recycling and reusing images as much as possible. One image, for example, can be used several different times throughout a project and remain "fresh" by using simple slight-of-hand tricks such as altering the magnification, cropping or color palette.

Charles McKittrick, Partner/Creative Director, AV Media, Los Angeles, California

In order to be able to fit a multimedia presentation with rich graphics onto a floppy disk, AV Media employed a wide range of space-saving tricks, including using as much scripting as possible.

ORGANIZING FILES

When developing multimedia titles, keep all your paths the same to make debugging and editing code easier. For example, . . . /images/logo/gif.

Haywood & Sullivan, Quincy, Massachusetts

DESIGN FOR MULTIPLE BROWSERS

It's a fact of web life that web pages look different depending on the browser being used. Some differences are astounding, especially where fonts and graphics are concerned. While you're designing the page, periodically check how your design looks in different browsers. You may want to include a warning note at the top of the page, saying something like, "This page is customized for viewing in Netscape."

You can download free samples of the latest versions of various browsers from the appropriate website. Use these to check your work so you don't have to buy all the different browsers. Make sure to check the pages in the latest version of the browser as well as one or two versions back. Many users don't upgrade immediately.

RESAMPLE ON-SCREEN GRAPHICS

Because they are displayed on screen and not printed, graphics for web pages and multimedia presentations need far less resolution than images that will be printed. Reduce the resolution and bit depth of print images you are incorporating into web pages or multimedia presentations. You'll save storage space, as well as retrieval time.

Use an image-manipulation program to resample the images. Maintain the size you want but experiment with different resolutions between 60 and 72dpi. Look at the images on different kinds of monitors to make sure they look good on a variety of displays.

ANIMATED GIF TIPS

Animated Graphic Interchange Format files (GIFs) are wonderful for adding life to a site. Use them sparingly, but have fun.
- Keep GIFs small and useful—don't make them a burden.
- You can get away with photos under 8 bits. Experiment and get the optimum resolution.
- Scale images in a photoediting program, rather than by using Hypertext Markup Language (HTML). Big images scaled down in HTML are still big images and will load much more slowly than prescaled images.

Talbot Design Group, Westlake Village, California

SAVING COLOR BACKGROUNDS

Any image that has the same color background as your web page background (e.g., buttons) should be saved as a GIF file. Joint Photographic Experts Group (JPEG) images tend to deteriorate, causing bleeding colors that dirty the background.

Tracy Burroughs, Little Men Studio, Redding, Connecticut

LOW-BUDGET ANIMATED GIFS

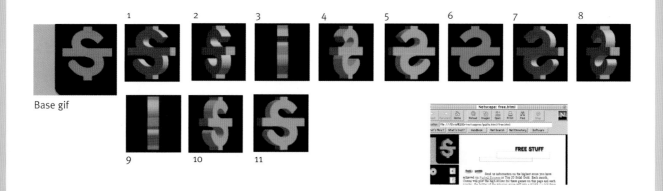

Base gif

Talbot Design Group created this animated GIF sequence using the technique described below.

Here is a way to create animated GIFs for websites without getting into costly programming.

1. Create images with a drawing or photo application (e.g., Adobe Dimensions, Illustrator or Photoshop).

2. When your frames are complete, transfer to Photoshop to change to GIFs and add any effects like lighting, lens flares, etc.

3. Add all frames in GifBuilder and save as an animated GIF.

4. Insert the GIF file into your site as you would any other GIF.

Talbot Design Group, Westlake Village, California

THE UBIQUITOUS DOT.GIF

Use "dot.gif" to force spacing in table layouts. Create a transparent, 1 × 1 pixel gif that you can stretch to force rows and columns into specific dimensions. Also, dot.gif can be useful for creating negative space in a layout.

Mike Zender, Zender & Associates, Cincinnati, Ohio

BE INTERACTIVITY-AWARE

Programming is the key to adding interactive components to CD-ROMs and the Web. Learning some scripting languages, like Macromedia Director's Lingo, or practicing with even just one computer programming language will make you more aware of the possibilities, limitations and costs of adding interactivity to your designs. This knowledge will also facilitate communication between designers and programmers working together on multimedia creative teams.

Mary Jo Fahey, writer/computer consultant, New York City. Mary Jo Fahey is author of Web Publisher's Design Guide. *The above is adapted from an article that appeared in the August 1996 issue of* HOW *magazine.*

USE PHOTOSHOP TO OPTIMIZE GIF FILES

When using Adobe Photoshop 3.x to create GIF files, it is recommended that you first go to the Adobe website to download the .gif89 export update. Once installed, the update allows you to use the "Export" function to save files in a more efficient format. Before using this function, you can use Photoshop's "mode" change to optimize files. Here's how:

1. Before translating your image to GIF format (using the 216 Web color CLUT), make sure to make duplicate copies of your original file.

2. After you have copied the file, change the format to "Indexed," then back to "RGB," then back to "Indexed Color." Photoshop will tell you how many colors are necessary to properly display that image. Without going through this process, Photoshop will use all 216 colors. If you have a complicated image, use the duplicate files to try different bit depths until you feel the image is beginning to lose too much quality.

3. After you are satisfied with the number of colors used (you'll be surprised what you can get away with), use the .gif89 export feature to save your file.

You can achieve some remarkable savings in file size with this process.

Kevin Farnham, MetaDesign, San Francisco

USE A LOGO AS AN ICON

When searching for icons to use as navigational aids or design elements, think about using the company's logo. You can use it by itself or incorporate it into a design. Make sure, though, that the logo looks good on screen and looks good reduced in size. If you can't use the whole logo, you may be able to use part of it.

CREATING SEAMLESS TILES FOR WEB BACKGROUNDS

If your background consists of very fine textures, you don't have to worry about it looking seamless when all the tiles are put together by your Hypertext Markup Language (HTML) authoring program. To make a seamless tile for a web page background, do the following:

1. Using a bit-map manipulation program like Adobe Photoshop, select a slice about ⅛ inch thick from the top part of the texture. Duplicate that piece and flip it horizontally. Now place it on the bottom of the tile. Using the cloning and airbrush tools, retouch the seam so that it is no longer visible, making the pieces you inserted undetectable.

2. Now select a ⅛ inch slice from the left side and follow the same procedure. Now test out your tile. If there are still imperfections, go back into your image manipulation program and make adjustments.

Tracy Burroughs, Little Men Studio, Redding, Connecticut

CREATING A SEAMLESS TILE FOR A WEB PAGE

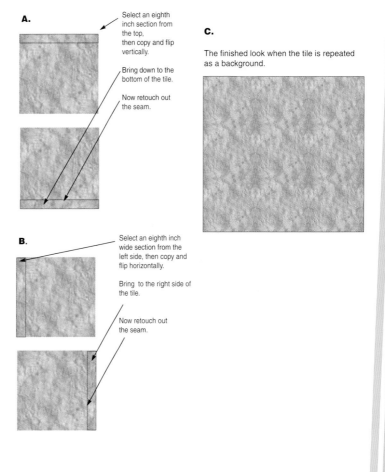

A.

Select an eighth inch section from the top, then copy and flip vertically.

Bring down to the bottom of the tile.

Now retouch out the seam.

B.

Select an eighth inch wide section from the left side, then copy and flip horizontally.

Bring to the right side of the tile.

Now retouch out the seam.

C.

The finished look when the tile is repeated as a background.

You can create seamless tiles for web page backgrounds by following these steps.

NAVIGATION STRATEGIES FOR WEBSITE DESIGN

Design multiple ways to get to various pages. Dead ends are a drag unless they are intentional and entertaining.

Talbot Design Group, Westlake Village, California

DESIGN A CLEAR DIRECTION

Nothing is as disturbing as feeling lost, confused or trapped. Navigational buttons or indicators must offer clear direction, as well as a way for the viewer to get out.

OPTIMIZE YOUR PALETTE

Palette optimization is essential for achieving good "reproduction" of bit map artwork within a limited 8-bit color mode. In the floppy multimedia presentation we created, all palettes were copiously customized for each individual image using Debabelizer. An 8-bit image is only as good as its palette, so we take the time to get the palette right.

To create a "flipbook" portfolio section, we wrote the script so that a customized palette was loaded for each new spread. We constructed the script so that each time the page turned the custom palette would fade to a gray-scale palette before the new spread's palette appeared. We thought of it as a little sherbet between courses. This avoided jarring color shifts, as well as prohibiting any one spread from being viewed (even for a fraction of a second) with another spread's palette. This trick also created a wonderful optical effect that enhanced the visual impact of the pages turning.

Charles McKittrick, Partner/Creative Director, AV Media, Los Angeles

PHOTOSHOP FOR WEBSITE LAYOUT

Most websites incorporate pixel images and pixel text along with the Hypertext Markup Language (HTML) text and links. Adobe Photoshop 3.0 can be used as a design tool for building images, but it can also be used as a production tool for establishing the layout and styles, following these steps:

1. Once the general layout has been built in Photoshop, create a new layer. Name this layer "HTML Page Grid." Duplicate this layer twice, calling the new layers "HTML Image Guide" and "HTML Style Guide," respectively.

2. On the HTML Page Grid layer, set the marquee tool to single pixel row or column. You can fill these selections with a solid color, creating a grid that divides the page into logical subdivisions based on image size, text location, etc. You can then use the Magic Wand to select the areas inside the grid cells, getting the pixel dimensions from the Info palette. Create type that shows the size of each cell and place it in that cell.

3. After you have created the individual GIF files for the text and images, create type that corresponds to the GIF file name and place it in the appropriate grid cell on HTML Image Grid layer.

4. The last step is to create type for the font, size, spacing, etc., of any text images. Place this information in the appropriate grid cells on the HTML Style Guide layer.

This system allows you to save out the grid layers and share them with the HTML coder(s) who may be creating the site while design refinement is occurring. It also sets up naming conventions, so that as images are updated, image links remain unbroken. It allows for easier communication of intended design between designer and coder. Note: When simulating actual HTML text and text links, choose a typeface common to your intended browser and do not anti-alias the type.

Patrick Newbery, MetaDesign, San Francisco

TYPE ON SCREEN

Certain fonts are more readable than others for screen designs. Helvetica, Times and Courier are good choices. Italic fonts and condensed fonts are not as good.

Keep text to a minimum. It's hard to read large amounts of it on a computer screen. If your presentation, demo or training program requires a lot of reading, consider making it a printed document instead.

Reprinted from The Basics of Color Design: Guidelines for Creating Color Documents, *a pamphlet published by Apple Computer, Inc.*

KEEPING ANIMATIONS SMALL

To keep the file size down in animated .gif89s, animate a small part of a larger image.

John L. Scott, Cofounder and Webmaster, alt.coffee, Inc., New York City

PUBLICIZING YOUR URL

Having a website is great, but only if your current and potential clients know you're there. When we had our website up, we designed a simple one-color business card exclusively to promote our web page. It has some graphics, but only our web address (no phone or snail-mail address).

Hal Apple, Hal Apple Design, San Francisco

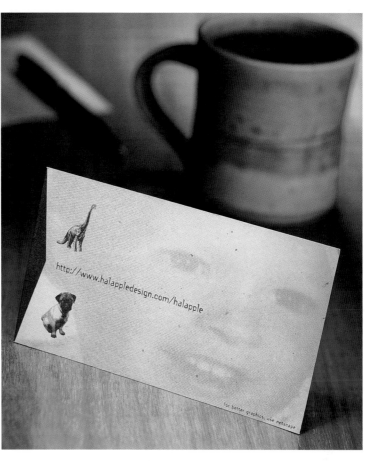

A business card with only your web address is a good tool for publicizing your firm's URL.

SHIFT THE VALUE OF THE BACKGROUND AND FOREGROUND COLOR

You can create transitions in a multimedia presentation by simply shifting (over time) the value of the background and foreground color of a given image. Many of the transitions we tried were much too slow. Anything we thought of to combine two images always turned out to be way too processor intensive, because the program had to churn through and combine two large bitmap images.

Our solution was to create fades using palette changes and even to create transitions by fading up and down the background and foreground values of a given set of images. If you're working with gray-scale images, this process essentially compresses the contrast by readjusting the white and black point. This created an accidental effect we found quite intriguing.

Charles McKittrick, Partner/Creative Director, AV Media, Los Angeles

ANIMATING TYPE? CREATE IT AS A FIELD OBJECT

In order to maximize the speed of animated type, use type as a "field object" rather than as "rich text." When working with type as "rich text," the type image is converted to a bit map at creation time, allowing you cleaner rendering (anti-alias) and more choices. (Your program only needs to be able to see the vector font—it doesn't have to be installed in the computer's system.) Speed then becomes an issue when you opt to animate or manipulate type of this sort, as the processor becomes overburdened with the task of constantly recalculating and rebuilding the bit-map display.

Using field text for all of the type animations allows you to use

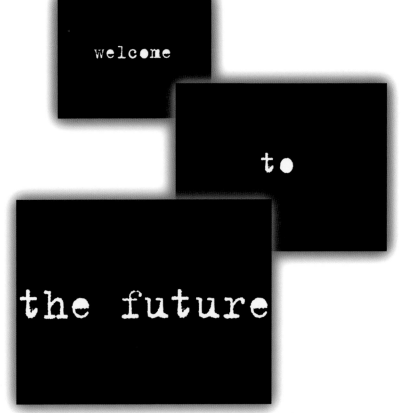

The type in this animation was created as a field text. This allows you to treat type as an object and speed up your animations significantly.

type as an object. This has the advantage of letting you alter and manipulate the properties of the field rather than having to constantly rerender bit maps. This limits you in terms of available fonts (fonts used in field text objects have to be available in the system) and quality of display (no anti-alias capabilities), but liberates you in terms of manipulation and speed because the field objects are only rendered at the time of play, not at the time of creation.

For example, in the opening sequence of our self-promotional multimedia presentation

(Welcome . . . to . . . the . . . future), we could have achieved the desired "zooming out" effect of the type in a number of ways. However, the only way to get the animation to run at an acceptable pace (on an average-speed processor, which we defined as a Quadra 950) with maximum space optimization was to engineer the animation using field-text objects with type within them.

Charles McKittrick, Partner/Creative Director, AV Media, Los Angeles

LINKS THAT HAVE (AND CREATE) VALUE

Have you followed link after link on the Web, feeling like you are being led farther away from the information you want rather than closer to it? Keep this in mind when designing your own web pages or making recommendations to clients regarding links.

People looking for information on the Web are generally trying to find ways to narrow down their searches, starting from one of the search engines and then either returning to the index of results or following links from one of the sites they've reached through the search engines. Make links reinforce or add to information the visitor has gained at your or your client's site. The user will remember the site as a satisfying and productive resource, not a jumping-off point to which she never returns.

SHARE YOUR SHAREWARE

Shareware is your friend. Change is the nature of the World Wide Web, and large software companies will never be able to produce and mass-market the tools you need fast enough to allow you to stay on the cutting edge of web technology. However, the shareware system allows one person's solution to a problem to be shared by everyone much sooner (and cheaper) than would otherwise be possible. Just don't forget to pay your shareware fees!

Mike Zender, Zender & Associates, Cincinnati, Ohio

GIF OR JPEG?

For on-screen presentation or World Wide Web pages, avoid large files because they take longer to load and download. Use GIF (graphic interchange format) for 8-bit (or fewer) images and JPEG (Joint Photographic Experts Group) for 24-bit photographic images.

OBJECT-ORIENTED PROGRAMMING

We achieved a "flip-book" effect for the digital portfolio section of our floppy presentation using object-oriented programming with the Lingo language. This created a structure with which it was very easy to work. A "flip" of the page is essentially a distortion of the properties of a given set of elements within the flip-book object. Because the distortion is repeatable, we can quickly update and revise the flipbook without having to rewrite code or redesign anything. The visual effect of the perspective shift of each page as it turns was ingeniously achieved (by our programmer) with the help of simple trigonometric equations—the type that engender bad high-school memories for most of us ($w=r*\cos(O)$).

Charles McKittrick, Partner/Creative Director, AV Media, Los Angeles

The "flip-book" portfolio section of the AV Media floppy disk presentation uses object-oriented programming. The portfolio can be updated without having to be redesigned.

"SMART" RANDOM SEQUENCE GENERATOR

The animated spread of the flipbook that displays our website home page was created using a smart random sequence generator. The generator was programmed to be smart in that we wanted the random placement of images to work within certain predefined limits: Only certain images could be placed in certain blocks; no two images could be used twice in the same space; the generator would stop once certain image/space combinations were achieved (with certain time limits).

Charles McKittrick, Partner/Creative Director, AV Media, Los Angeles

The animated flip-book spread that displays the AV Media home page was created using a random sequence generator.

Chapter Eight

SCANNING

TIPS ON HOW AND WHAT TO SCAN

As they have become more and more affordable, scanners have become standard in desktop publishing and design offices. Getting the most out of your scanner requires some technical knowledge of resolutions and some experimentation with materials to see what works and what kind of effects you can achieve. This chapter includes both technical tips and tricks for creating interesting images and backgrounds with your scanner.

THE BEAUTY OF METAL

For a brochure for the American Institute of Steel Construction, which was designed to showcase and promote the beauty of the metal, we chose not to commission photography for the detailed shots. Instead, we scanned a variety of actual metal samples, placing them (very carefully!) on the scanner and then printing in four-color process.

Sayles Graphic Design, Des Moines, Iowa

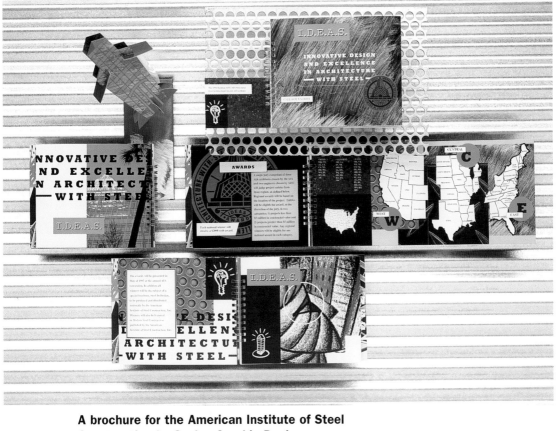

A brochure for the American Institute of Steel Construction by Sayles Graphic Design uses scans of actual metal samples.

SCANNING LINE ART

Because they can only be black and white, line art scans do not have the luxury of anti-aliasing (a technique that makes smooth transitions between black and white by adding varying steps of gray). Therefore, they are prone to having jagged edges around curves when scanned at lower resolutions than the final output device. Line art should be scanned at as high a resolution as the final output device to eliminate the jagged effect. If your original art is 5" × 7" and you're going to output at 5" × 7" on a 1,200dpi imagesetter, ideally the art should be scanned at 1,200dpi. If your original is larger than the final image size, adjust the scan resolution proportionally so as not to have more resolution than necessary.

Reprinted with permission from The Scanning FAQ (http://www.infomedia.net/scan/The-Scan-FAQ.html), compiled and maintained by Jeff Bone.

BE SAFE: USE A TRANSPARENCY

When you don't know every use an image might be put to, but you know you need to make color separations from it, ask the photographer to shoot a transparency of the image and scan from the transparency rather than from a print. Transparencies are first-generation originals, while prints are second generation.

Based on material in the S.D. Warren book, A Team Approach to Photography for Reproduction, *and material contributed by Baldo Photography.*

GANG SCANNING FOR EFFICIENCY

When you need to scan more than a few items, sort the images into groups of similar types before you start. For example, you could put all high-key transparencies into one group and all low-key photographs into another. Start with one group and scan all the items in that group before moving on to the next group. Organizing your work this way allows you to make only minimal changes to the scanner settings while working with the objects in a group. Experiment with the groupings to find the most efficient work flow for you.

PREPARING PRINTS FOR DRUM SCANNING

Do not mount prints that will be scanned on a drum scanner. They must be wrapped around the drum in order to be scanned. Make sure the prints are free from cut marks, scratches and fingerprints. Remind the retoucher the images will be scanned so he can make them "scanner proof."

Based on material in the S.D. Warren book, A Team Approach to Photography for Reproduction.

SCANNING FOR LASER OR INKJET OUTPUT: DON'T OVERSCAN

When scanning for output on a laser or inkjet printer, don't overscan the image. Figure out what the optimum scanning resolution is for the 300dpi or 600dpi output device you have and scan at that resolution.

DETERMINING YOUR DYNAMIC RANGE NEEDS

The dynamic range of a scanner is an indication of the tonal range of the original image that the scanner is capable of capturing. By tonal range we mean the detail between the highlight and the shadow areas. The dynamic range you need depends on the type of original you use and the intended end-use of the scan. Here are some guidelines.

Vacation-type transparencies like slides tend to be more exposed and have low density ranges. If these images are to be used in a newsletter, a low-end scanner might be sufficient. If the intended use is in a magazine where different film types and less than ideal conditions are encountered, a midlevel scanner would be better.

For professional studio shots, publishers are intent on getting the maximum quality from the film. Scanning these requires a scanner with a high dynamic range. Professional model scanners are used a lot in the publishing market because of their raw scanning speed and ability to accomodate gang scanning.

Excerpted with permission from SpectraComp Technical Tips, published by SpectraComp. SpectraComp Technical Tips provides timely information on imaging topics and can be found on the Web (http://www.SpectraComp.com).

SCANNING NEGATIVES

Scanning negative film is one of the most difficult captures to do successfully. For starters, negative scanning requires the scanner to inverse the negative to a positive digital file. Unfortunately, it's not as easy as making white black and black white. Different film manufacturers have different color standards, and even film from the same manufacturer can vary from batch to batch. The end result is that negative scans often have serious color casts that require manual interven-

tion. If you anticipate scanning negatives, look for a scanner that allows you to gray balance for the exact piece of film on your bed. By analyzing the edge of the film, a scanner is capable of generating a look-up table precisely for that piece of film. This will eliminate any color shifts involved with negative scanning.

Reprinted with permission from the G & R Technologies scanning tips web page (http://www.gnr.com/scntips.html).

AVOID SCANNING PREPRINTED ART

Halftone scanning evolved because someone discovered they could scan photographs from magazines. Using prepublished images without permission is a violation of copyright law. Assuming that you have permission to use a preprinted piece, you still shouldn't—instead, ask for the original photograph. If your goal is publication-quality work, halftone scanning should always be used as a last resort.

Excerpted with permission from The Scanning FAQ (http://www.infome dia.net/scan/The-Scan-FAQ.html), compiled and maintained by Jeff Bone.

SCAN FLAT OR ROUNDED OBJECTS

Using your desktop scanner, you can save time and money by scanning some flat or round objects instead of photographing them. You can use an image-editing program to improve the quality of your scans using the color-altering functions, light and contrast, airbrushing, paintbrush, cloning and smudge tools.

Tracy Burroughs, Little Men Studio, Redding, Connecticut

CREATING A UNIQUE IDENTITY SYSTEM STARTING FROM SCANNED FABRIC

We love texture, so in creating our identity system, we started with a piece of unique fabric in our custom office decor and scanned it on our flatbed scanner. Here's how we did it:

1. To create the pale background, we converted a piece of the fabric scan to gray scale in Adobe Photoshop and then screened it back 5 percent.

2. We took a piece of tissue and used a black marker to scribble a design on it. We then photocopied that many times to get the desired effect, then scanned the photocopy and brought it into the same Photoshop file and reversed, lightened and layered it over the fabric background to achieve a soft look.

3. To create the partial faces image in the corners, we brought the original fabric scan into Photoshop and converted it to a gray-scale image, then a duotone. We also blurred the image to use on the reverse side of our stationery.

4. We created a white arch in Adobe Illustrator to form the unusual corner angle and add visual interest to the pattern underneath it.

5. All elements were assembled in QuarkXPress and final type additions were made.

Talbot Design Group, Westlake Village, California

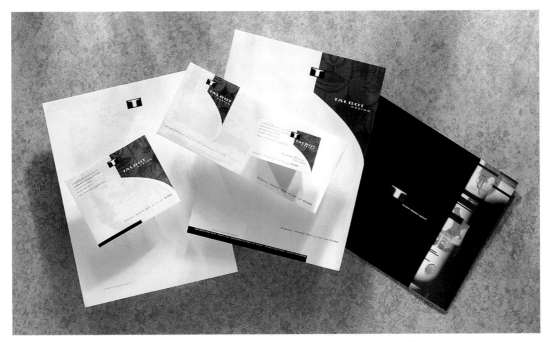

Talbot Design Group's identity system uses scanned fabric from the firm's office decor as a background.

DECREASE THE TONER SETTING FOR PRINTING GRAY-SCALE IMAGES

If you're printing a gray-scale scanned image on a black-and-white printer, try decreasing the toner density setting on the printer to get a slightly lighter image than normal. Look for this setting in the utility software that comes with the printer or look for a dial inside the printer.

WHEN TO USE A DRUM SCANNER

The more expensive flatbed scanners are now almost as good as drum scanners for most images. There are two situations in which you're better off using a drum scanner:
1. When you must have the highest possible image quality (when only the best will do).
2. When your image will be enlarged many times its original size. If you're going to create a poster-size image from a postage-stamp-size original, have the scan done on the best drum scanner you can find/afford.

HIGH OR LOW?

Many people say you should scan at a resolution that is twice what the line screen will be when your piece is printed. I scan at 150 percent. The results are perfect and it keeps down the size of the documents. Remember that you can always decrease the resolution of a scan and maintain quality, but if you increase the resolution of a low-res scan more than 10 to 25 percent, the result will look soft or blurred. (Depending on the art, you may be able to fix this with a sharpness filter and a little retouching.)

Tracy Burroughs, Little Men Studio, Redding, Connecticut

SCANNING FOR LARGE-FORMAT OUTPUT: REMEMBER THE FUDGE FACTOR

If your final output is a poster, the dictum "never scan outside the scanner's optical resolution" may not hold true in all cases. Keep in mind that posters are generally viewed from a distance of three to five feet away. This provides a "fudge factor" in which the viewer cannot perceive the quality difference.

Adapted from material on the G & R Technologies scanning tips web page (http://www.gnr.com/scntips.html).

TOO MUCH DATA ADDS TIME AND COST

Most of us scan at too high a resolution. As we increase scan resolution, we capture too much detail and the scan files balloon to outrageous sizes. The imagesetter or laser printer must render all of that data, using lots of costly RIP time. As you work with a scanned image, the computer constantly has to recrunch the scan data. Over the course of a project, this time really adds up. Scans with way too much data not only rob your time, they can even crash your RIP—in which case you don't even get a page. Take a few moments to calculate what you need rather than scanning at high detail just to be on the safe side. Capture just enough detail for what you need.

Reprinted with permission from The Scanning FAQ (http://www.infomedia.net/ scan/The-Scan-FAQ.html). The Scanning FAQ is compiled and maintained by Jeff Bone.

CROP IMAGES TO ELIMINATE WHITE SPACE

The white space in an image is data that will have to be computed by your RIP (raster image processor) or other output device when it comes time to print. Crop the image in an image-editing program to avoid having the RIP compute all that white space.

Reprinted with permission from The Scanning FAQ (http://www.info media.net/scan/The-Scan-FAQ.html). The Scanning FAQ is compiled and maintained by Jeff Bone.

STUCK WITH A PRINT?

It's always better to use a scanned image made from a transparency, but you can make good images from a print. Reproduce it at the same size, if possible. Enlarging it will only make it look worse. Reducing it considerably (by a third) may make it look muddy when printed.

Based on material in the S.D. Warren book, A Team Approach to Photography for Reproduction, and material contributed by Baldo Photography.

PHOTO CD VS. DRUM SCANS

Using Photo CD images rather than drum scans can save you a lot of money for the majority of your color projects, including brochures, catalogs and direct-mail pieces. However, for print projects larger than 10" × 15" or for high-end annual reports, drum scans are recommended.

Based on material contained in "Tips on Preparing Photo CD Images for Print Reproduction," available from Westlight Creative Services, (800) 278-2893.

SCANNING LINE ART IN GRAY-SCALE MODE

Capturing a small piece of line art (for instance, a logo) on a desktop scanner and reproducing it at a size larger than the original is a challenge. If your scanner does not support high optical resolution or the reproduction size is considerably larger than the original, you often get pixelization (jaggedness resulting from the pixels being visible) at the edges of type or lines. One way to eliminate this problem is to scan the art in gray-scale mode instead of in line-art mode. When you change the mode from gray-scale to bit map, you will have the equivalent of a line-art scan, with fewer jagged edges. Using a tracing program like Adobe Streamline or ScanVec Tracer, you can convert the scan to vector art, which is ultimately the best format for type and line art.

Reprinted with permission from "Tips for Scanning Line Art" by John Stoy, Computer Artist, *October/November 1996. John Stoy is founder of Desktop Prepress Associates, a consulting and training firm based in Fairport, New York.*

SCANNING FOR HEXACHROME OUTPUT

Because of the enhanced color range available with printing in Hexachrome, you'll want to configure your scanner to create RGB files when your piece will be printed in Hexachrome. This will provide a broader color gamut than corrected CMYK and will better exploit the Hexachrome color range. Most scanners create RGB files easily. If yours does not, consult the manufacturer.

Reprinted with permission from HOW *magazine, December, 1996. Based on information provided by Pantone, Inc.*

IMAGE-EDITING VS. PAGE LAYOUT PROGRAMS FOR CROPPING SCANS

Avoid using a layout program to crop a scan, because these programs merely mask an area and do not decrease the amount of data the RIP must compute.

Reprinted with permission from The Scanning FAQ (http://www.infomedia.net/scan/The-Scan-FAQ.html), compiled and maintained by Jeff Bone.

SMOOTH YOUR EDGES WITH INTERPOLATED SCANNING

Because it provides more data points, interpolation can help smooth jagged edges in line art and photos, especially if you're going to enlarge the image. You should consider interpolated scanning if your work involves a lot of detailed line art—especially if you autotrace the artwork in programs like Adobe Streamline, Adobe Illustrator or Macromedia Free-Hand. Interpolation can clean up the edges considerably, so your autotraces are truer to the original image. And if you perform interpolation on images in a program like Adobe Photoshop, doing it in the scan saves you the step of doing it in the software.

Reprinted with permision from FYI: Interpolated Scanning, published by PrePress Solutions on the PrePRESS Main Street website (http://www.pre press.pps.com).

SCANNING ORGANIC AND INORGANIC IMAGES

In this spread for the 1995 Columbus Society of Communicating Arts Commemorative Catalog, the large organic shape is a scan of a woman's eyelash. The hair pin was scanned directly on the scanning glass.

Kirk Richard Smith, Firehouse 101 art+design, Columbus, Ohio

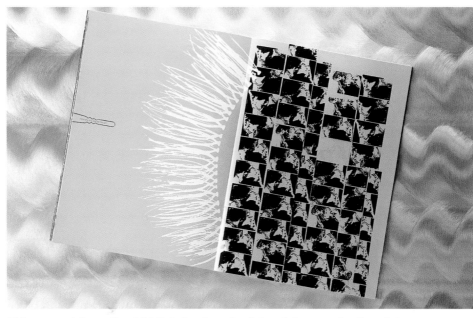

This spread from the 1995 Columbus Society of Communicating Arts Commemorative Catalog, designed by Firehouse 101 art+design, features a scan of an eyelash as well as a hair pin that was scanned directly on the scanning glass.

COLLAGING SCANNED IMAGES

For this spread for the 1995 Columbus Society of Communicating Arts Commemorative Catalog, we scanned an old letter and a photo found at a flea market, then placed the images in QuarkXPress. We placed Lucky Charms cereal icons on top of a scanner bed for a high-resolution scan, then color-enhanced the image in Adobe Photoshop.

Kirk Richard Smith, Firehouse 101 art+design, Columbus, Ohio

Materials that were scanned for this spread from the 1995 Columbus Society of Communicating Arts Commemorative Catalog include an old letter and photo found at a flea market and Lucky Charms cereal icons.

ADD NOISE TO CHEAT THE EYE

Adding noise to a scan minimizes the transitional steps between gray-scales. Illustrators and four-color shops will often use this technique to smooth low-resolution scans. An example of this technique in use is the following: If you have created a blend in your illustration package that has only thirty steps, you can export the EPS file into your favorite image editor and add one or two units of random noise with the noise filter to take away the hard edges and cheat the eye. This works well for either ultra-high or very low resolution scans that either exceed the gray level of your imagesetter or produce very pixelated images.

Reprinted with permission from The Scanning FAQ (http://www.infomedia.net/scan/The-Scan-FAQ.html), compiled and maintained by Jeff Bone.

INCREASING THE DYNAMIC RANGE OF PHOTO CD IMAGES

A Photo CD scan has a dynamic range of 2.8 compared to 3.2 for a drum scan. For the Photo CD this results in a loss of details in the shadows. Photo CD also lacks a true black point and sometimes a white point. Setting the points that should be black as black will give the illusion of a wider dynamic range. You can intensify the contrast in Adobe Photoshop using Levels.

Excerpted from "Photo CD Empowers Designers," HOW magazine, June 1996; based on information contained in "Tips on Preparing Photo CD Images for Print Reproduction," available from Westlight Creative Services, (800) 278-2893.

GANG SCANNING RESTRICTIONS

Gang scanning can save you up to one-third in scanning costs, but there are some restrictions to bear in mind: You can only gang like elements—transparencies, photographs or original artwork—and every piece must be sized to the same percentage. For good results, subjects should also be compatible in subject, lighting and density. If you have one piece that is critical and others that are of lesser importance, you can ask the scanner operator to calibrate his equipment focusing on the primary piece and let the others "ride along"; of course, the secondary pieces may suffer in the process.

Reprinted with permission from Step-By-Step Graphics, May/June, 1996.

PREPRESS

GETTING THE BEST RESULTS WITH THE FEWEST HEADACHES

How many times have you gotten proofs back from your service bureau only to see with horror that the colors in the proof aren't what you thought you were getting? How many times has your service bureau had to call to ask you to modem the fonts that you forgot to include or that it can't output properly? Prepress problems are the last thing you need when you're on deadline. Follow the advice of designers and prepress specialists to avoid production headaches and get better output.

CALIBRATION: THE CRUCIAL STEP IN DIGITAL PHOTOGRAPHY

The advantage of digital photography over traditional film-based photography is that it gives a wider color spectrum and allows the designer to know better beforehand what the colors will be. However, getting the results you want requires that the photographer, color separator and printer all calibrate their equipment to one another's. Without this crucial step, designers have no more idea of what the printed piece will look like than they do when they look at a transparency.

Jeff Kauck, Kauck Productions, Cincinnati, Ohio and Chicago, Illinois

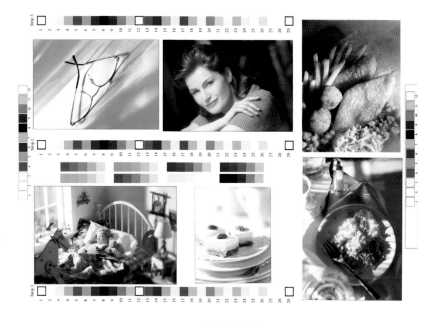

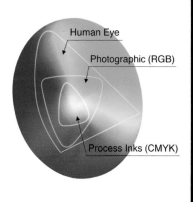

The color chart shows the wider spectrum of colors that digital photography can capture. Benefitting from this wider choice, however, requires precise calibration of the photographer's equipment to the service bureau's and printer's.

TONE COMPRESSION: WHY YOU CAN NEVER GET WHAT YOU CAN SEE

Outside on a sunny day, the ratio between the lightest tone the human eye can detect and the darkest can be as high as 1000:1. Film and photographic paper reduce the range to at most 100:1. The printing process, involving scanning, screening and printing, reduces it to perhaps 20:1. Tone compression, the technical term for this progressive reduction, can be minimized in two ways. One, use a duotone, tritone or quadratone to produce exceptionally deep shadows and expanded tonal range. Two, use a fine screen ruling—the more dots the image contains, the greater the tonal range.

Condensed from the S.D. Warren book, A Team Approach to Photography for Reproduction.

IMAGING COLOR SEPARATIONS

If you can't image a color file as color separations, try printing each separation separately. Use your page layout or color separations software to image the separations one at a time as separate jobs. The imagesetter or printer may not have enough memory to handle all the separations, but may have enough to rasterize an image at a time. Make sure that you run all the separations out one right after another to avoid misregistration problems.

SPECIFYING SPOT COLOR

The best way to specify spot colors accurately is to use a spot color reference guide. It is critical that the colors' names and numbers be specified in the layout or illustration software.

The most common errors in defining desktop colors are easily avoided. Often, the Process Separation button in layout programs is overlooked. If it is set to ON, every color—including spot colors intended to be printed as spot colors—will be printed as a CMYK separation. Spot color must be specified as such, by setting the Process Separation button (in QuarkXPress) to OFF so the color will not be generated as a CMYK match.

Reprinted with permission from The Warren Standard, Volume Two, No. Five: A Guide to Electronic Prepress, *published by S.D. Warren Company.*

A BEAUTIFUL PHOTOGRAPH, A LOUSY PRINT JOB?

An image printed by traditional offset processes is limited to a range of about four f-stops (or a 1.9 density). Areas or tones outside this range are lost. Press, ink and paper cannot reproduce as full a tonal range as film can capture.

Condensed from the S.D. Warren book, A Team Approach to Photography for Reproduction.

WHEN IN DOUBT, ORDER A MATCHPRINT

No matter how your color appears on your display, and how well-calibrated your hardware and software are, you still should not expect the color to appear the same as it would for final output. If in doubt about the color being appropriate, order a matchprint to be sure how your design will look when printed. The advantages outweigh the expense.

Rebecca Ranieri, Faith Writing and Design Studio, Norristown, Pennsylvania

TYPES OF COLOR PROOFS

Thermal-transfer proofs or desktop inkjet printers provide a rough idea of your job's color early on. For greater color accuracy, Fiery calibrated color laser printers or dye-sublimation prints are effective, but still too inaccurate for final sign-offs. Better yet are high-resolution color inkjet proofs (Iris proofs) and digital prepress proofing systems. Cromalin proofs are based on colored toner powders and can vary according to the skill of the practitioner. Digital proofing systems like the Kodak Approval Proof can accurately represent line screen, dot structure, trapping and even dot gain on different papers.

Adapted with permission from The Warren Standard, Volume Two, No. Five: A Guide to Electronic Prepress, *published by S.D. Warren Company.*

CORRECT FOR DEVICE-SPECIFIC COLOR WITH A COLOR MANAGEMENT SYSTEM

Each component in the prepress system, working within its own color space and gamut, produces color that is device-specific. That is, if you scan a photograph of a magenta hat, the scanner represents the magenta with a certain set of data. When you display that image on your screen, the magenta is represented by another set of data, and the two magentas appear to be of different hues. When you print the image on a color printer, a third set of data is used to represent the magenta, and a third hue appears.

A color management system (CMS) corrects for differences in device-specific color so that the image on your monitor can be trusted to match the original source or the final color proof. The CMS does this with the following steps:

1. Using a standard color-definition mode.
2. Using profiles that represent the color characteristics of different devices.
3. Incorporating transformation algorithms that translate colors from device to device.

Let's say your prepress system consists of an Optronics Drum Scanner, a Power Macintosh workstation running Adobe Photoshop, a PrePRESS Panther Plus Imagesetting System and a color proofing system. The CMS runs on the workstation, and it includes the device profiles for all the components. When you scan an image, the CMS reads the profiles for the scanner, monitor and proofing system and translates the image's colors to display on your monitor as they will appear on the color proof. As you adjust colors to get the image right, you can trust the screen colors to reflect the proof image. Since you do not have to rely solely on CMYK percentages, you can reduce your iterations through the proofing cycle.

Time and materials savings represent the practical, economic benefits of a CMS. Another benefit for many Mac- and PC-based publishers is the CMS's ease of use; it allows you to work with the natural colors with which you are comfortable.

Reprinted with permission from FYI: What Is Color Management, published by Prepress Solutions on the PrePRESS Main Street website (http://www.prepress.pps.com).

KNOW YOUR PAPER WHEN PROOFING

Knowing how paper will perform is as essential to effective prepress proofing as selecting the right color. Since each grade of paper behaves differently, it's wise to select a proofing system that accurately depicts the sheet's dot gain, holdout and surface texture.

Adapted with permission from The Warren Standard, Volume Two, No. Five: A Guide to Electronic Prepress, *published by S.D. Warren Company.*

KNOWLEDGE OF FORMATS HELPS IN TROUBLESHOOTING

Learn everything you can about the proper way to build electronic files, graphic file format compatibility and compression file format characteristics so you can troubleshoot problems you may encounter in output or in working with others who may need to use your files.

Rebecca Ranieri, Faith Writing and Design Studio, Norristown, Pennsylvania

CHOOSING A SERVICE BUREAU

Finding a service bureau that meets your prepress needs and that you know you can count on will save you enormous headaches when you're on tight deadlines. Here are a few rules for choosing the right one.

Rule #1: Make a site visit.
Ask to see the work area and not just the wonderful, expensive equipment. Ask how many people work per shift and how many shifts there are. If the service bureau you are thinking of using won't let you visit and take a guided tour, assume the worst and go elsewhere.

Rule #2: Pick a service bureau before you need one.
Even if you have a fully equipped prepress shop, remember that equipment breaks at the worst possible time. Visit a couple of service bureaus in your area and get to know them before you need them.

Rule #3: Make sure your software is compatible with the service bureau's software.
Before you settle on any desktop publishing package, check around and make sure the software is being used in more than one service bureau in your area. Otherwise, you may have the most powerful software on the planet, but you won't get your files output properly.

CHECKING COLOR SEPARATIONS WITHOUT AN IMAGESETTER

You don't need an imagesetter to check color separations. Print the file as separations to a black-and-white laser printer. You'll get a black-only sheet for each color. Check each separation to make sure all imported graphics and document files have been created using the same color library and appear on the appropriate separation.

For example, PMS 240 uncoated is a different library and will appear on a different separation than PMS 240 coated or PMS 240 CMYK separation.

Cathy Cotter, Cotter Visual Communications, Landenberg, Pennsylvania

GETTING THE RIGHT FONTS PRINTED

Getting the best font output from a service bureau can be tricky. The files you lovingly created and nurtured in your office can refuse to print or look unbelievably bad if they do print. Here are some steps you can take to make sure the type you get back from the service bureau is acceptable:

• Don't mix fonts from different companies to make up one typeface. For example, don't use Adobe's Garamond regular and bold and LaserMaster Garamond light in the same document. Doing so makes the printed results unpredictable.
• Don't rename fonts.
• Take the time to collect and send along the font files used in the document, along with a list of the fonts used.
• If you use TrueType fonts, make sure the service bureau can image them properly. Some PostScript RIPs don't support TrueType and will substitute the Adobe version of the font, resulting in copy flow and spacing changes.
• If you create your own fonts, give both the screen and printer versions unique names to avoid confusion with industry standard names. Don't forget to send both the screen and printer versions along with the file in which the homegrown fonts are used.

Adapted from material provided by the Scitex Graphic Arts Users Association.

CALIBRATING YOUR MONITOR WITH PHOTOSHOP'S "GAMMA"

No matter what hardware you have, you need to spend time and effort to make your display the best that it can be. If the colors are inaccurate, you'll end up making color changes based on false impressions.

Adobe Photoshop provides an easy-to-use software utility called "Gamma." Gamma lets you adjust the color balance of your monitor, as well as make black point, white point and gamma adjustments. Every time you start up your computer, Gamma adjusts the monitor based on your settings. Simply open a few digital files in Photoshop, and adjust the Gamma controls until the images on screen match your printed samples. Try to use photos that offer a wide variety of colors and densities. Once Gamma is set, don't fiddle with your monitor's brightness and contrast dials or you'll throw off the calibration.

Two more things to remember: Change your desktop color to a neutral gray background so that it doesn't interfere with your color perception, and be sure to let your monitor warm up for at least half an hour before starting any color work.

Kirk Lyford, Vivid Details, Ojai, California. Reprinted with permission from Vivid Details: Prepress Article on Calibration on the Vivid Details website (http://www.vividdetails.com).

WATCH SPOT COLOR CONVERSIONS

Significant color shifts occur when spot colors are converted into their CMYK equivalents, and some convert more readily than others. Using a process conversion reference guide will help predict the actual tone and value you'll see on press.

Adapted with permission from The Warren Standard, Volume Two, No. Five: A Guide to Electronic Prepress, *published by S.D. Warren Company.*

LET THE EXPERTS DO IT

Let a good prepress house do the work, unless, of course, you'd rather spend your time in production than in design. It depends where your skills and talents lie. And, of course, what you enjoy doing.

Rick Tharp, Tharp Did It, Los Gatos, California

FILE TRACKING

When preparing files for clients or service bureaus, include a current printout of the contents of each disk with the disks themselves, especially if the project is complex (twenty or more related files). To make a printout, click on the disk icon, arrange the screen so that all the file names are visible and do a screen dump. When many files and several disks are involved, consider color-coding file types with highlighters: yellow for art, green for fonts, orange for photographs, etc.

Cathy Cotter, Cotter Visual Communications, Landenberg, Pennsylvania

CALIBRATE FOR CONSISTENCY

Each output device will produce film with a different density, which in turn, will alter the color. Even the same machine varies from day to day, depending on the consistency of the light source, the batch of film used, the age of the chemistry, or even the temperature.

Your best bet is to find a reliable service bureau that calibrates their system every day. Then run a few test pages through their system and calibrate your monitor to the test results. At a set time interval, like every month, run the same test page through their system. This could also help your service bureau. The file should look the same from month to month if everything is calibrated accurately. Run the same test procedure before you begin a big project.

Kirk Lyford, Vivid Details, Ojai, California. Reprinted with permission from Vivid Details: Prepress Article on Calibration on the Vivid Details website (http://www.vividdetails.com).

FILE OUTPUT DOCUMENTATION CHECKLIST

When turning files over to a service bureau, make sure you include the following in your documentation:

- Full-size (100 percent) laser proofs (color is possible).
- Black-and-white proofs printed with "Print Colors as Grays" on.
- If the file is sent via modem, a printed proof must follow. Be cautious of relying on a fax.
- An oversized document has been tiled, not reduced in size.
- Registration marks in place.
- Proofs are properly marked up, identifying live vs. FPO images and color specifications.
- Printed directory of contents of disk/cartridge.
- Electronic file sheet, completely filled out.

Reprinted with permission from The Warren Standard, Volume Two, No. Four: Digital Weights and Measures, *published by S.D. Warren Company.*

GETTING GOOD FIERY PROOFS

Make sure the service bureau you use is comprised of professionals in the field. Some quick-print shops offer Fiery prints for less money than service bureaus, and the quality suffers.

Tracy Burroughs, Little Men Studio, Redding, Connecticut

COLOR MATCHING

For the best color matching, make sure your color swatch books are current. The rule of thumb is to replace the swatch book once a year to make up for fading inks, fingerprints and other damage. If you don't know which book to use, ask the print shop you use or plan to use.

Condensed from The Underground Guide to Color Printers, *David M. Stone, Addison-Wesley Developers Press.*

CHECKING TRAPS

To check traps without having to output film on an imagesetter or matchprint, enlarge the entrapped area and print each separation on a different sheet of transparency film. Arrange the sheets in the order the trap should occur and look at the sheet on a light table. Check to make sure the traps are adequate and work the way you intended.

DOT SHAPES AND SKIN TONES

Screens with elliptical dots are often used for images with lots of skin and flesh tones. They create more gradual transitions from tone to tone than conventional halftone dots that are almost square. If skin tones look blotchy or uneven and they shouldn't, check to see what dot shape was used when the photograph was scanned or reproduced on an imagesetter.

Based on material in the S.D. Warren book, A Team Approach to Photography for Reproduction.

BUILD A COLOR REFERENCE FILE

Color tests can be output in the different proofing formats for future reference. Keep copies of press runs and proofs to build reference files.

Adapted with permission from The Warren Standard, Volume Two, No. Five: A Guide to Electronic Prepress, *published by S.D. Warren Company.*

EXAGGERATE A LITTLE

In going from an original photograph or illustration to film to plate to blanket and finally to paper, something is lost at each stage. To get the images in the final piece to look more like the original, exaggerate a little at each stage.

KAISERDICKEN, Burlington, Vermont

RIP PROBLEM WORKAROUNDS

If the file you've created absolutely refuses to image properly on an imagesetter or other high-resolution output device, here are a few things to try before giving up and going back to the drawing board.

1. If it's a multipage file, image one page at a time.

2. If the job contains more than one color, output only one color separation at a time.

3. Try running the job at a lower resolution than you need. At least you'll know the file images. Perhaps the imagesetter needs more memory to run the job at a higher resolution.

SCREENING FOR HEXACHROME PRINTING

Use conventional screens as well as stochastic screens for Hexachrome printing. To avoid moiré, assign the same screen angle to colors that don't print together like orange/cyan and green/magenta.

Reprinted with permission from HOW magazine, December 1996. Based on information provided by Pantone, Inc.

Chapter Ten

MISCELLANEOUS

ETIQUETTE, ATTITUDE, CLIENTS AND MORE

Miscellaneous: It's exactly what it says—a grab bag of tips on etiquette, attitude, client relations and hands-on tricks about everything from finding low-cost materials to cutting the corners off your comps. Whatever didn't fit neatly into a category is here. Don't let the lack of specificity discourage you: We saved some of the best for last.

FINDING INEXPENSIVE, GENERIC MATERIALS

In an effort to design a great-looking, multiple menu program within a tiny budget, we went in search of inexpensive paper for the menu covers. If you dig around a bit, you can find some great generic items that you can customize cheaply in places like stationery stores, dime stores or restaurant supply stores. We used inexpensive stock coffee-shop-style vinyl sleeves with different inserts made of dime-store contact paper and vintage wallpapers. This allowed us to have a series of four-color covers at a very low cost. We created the type with simple film laser prints that we made in-house and slipped into the sleeves over the various wallpapers.

Carol Bokuniewicz, Carol Bokuniewicz Design, New York City

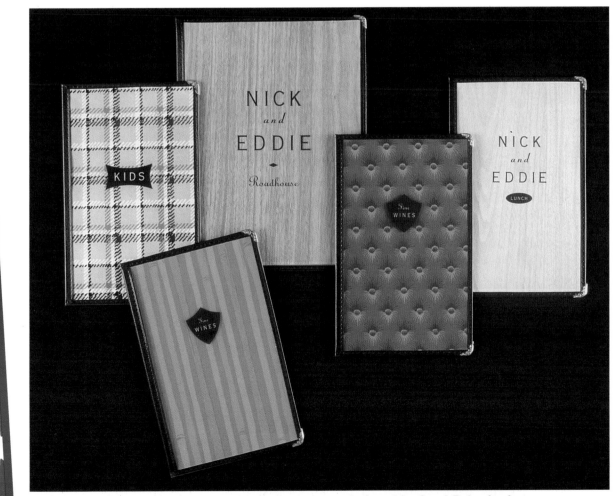

The materials for these low-budget menus designed by Carol Bokuniewicz Design included stock coffee-shop-style vinyl sleeves and inserts made of contact paper and vintage wallpaper.

AVOID "ASSUMPTION DYSFUNCTION"

How often have you begun a project with the client across the table, both of you grinning, full of excitement and high expectations about the project's outcome, only to see the creative biorhythms slowly dip below the baseline into the zone of mediocrity? You both suffered from "assumption dysfunction." You saw the piece in your mind's eye; the client saw it in his.

The only way to keep a project from sinking is to start it off on solid ground. Ask the client more questions about the project than your mother asked you about the first person you ever dated. Be sure you both define your expectations.

Mel Maffei, Director, Keiler Design Group, Keiler and Co., Farmington, Connecticut; adapted from material published in HOW *magazine, October 1996.*

THANK YOU NOTES GO A LONG WAY

I've found that only one out of fifty people who I interview for design positions ever sends me a thank you note. I assume that clients are often neglected, too. So, we do two things at a minimum as follow-up:

1. Send a fax thank you. It simulates an eye chart and is pretty immediate.
2. Send a thank you note with a five-dollar stamp of an apple.
3. For corporate executive types, I send a hand-written note with a stamp and sealing wax. I usually get a call back.

Hal Apple, Hal Apple Design, San Francisco

Hal Apple Design sends a fax "thank you" in the form of an eye chart as an immediate follow-up to client meetings. A more formal thank you note follows.

WORKING IN TEAMS

Working as part of a team to create and produce a design can be stressful. Here are two tips for controlling your stress level and producing better designs.

1. Talk about the project in detail with other members of the team. Tell them everything, even information you're not sure they need to know. Don't talk just about the project, either. Keep the avenues of communication open at all times.

2. Keep the client's expectations in mind. If your client wants a tri-fold brochure, that's what you need to deliver. When you're part of a team, it's easy to get carried away and create something the client didn't order.

YOU ARE PART OF YOUR PORTFOLIO

No matter how great your portfolio, if you don't present yourself well, you don't make a good professional impression. Consider your appearance and your attitude as part of your presentation, too.

Rebecca Ranieri, Faith Writing and Design Studio, Norristown, Pennsylvania

WORKING WITH CLIENTS

Following a few simple rules will vastly improve your relationship with your clients.

1. Drive a less expensive car than your clients.

2. Always do the best job you can, regardless of the budget. No one but you and your client knows, or cares, what it cost.

3. When presenting to your client, don't present ideas or designs that you don't want selected. There's no need to impress clients with your prolific output at the risk of having a bad design selected. If we only have one good idea, that's all we show.

4. Don't miss deadlines and never, never say you can do things you can't do.

Rick Tharp, Tharp Did It, Los Gatos, California

BALANCING VALUES TO BALANCE YOUR DESIGN

Your values determine the course of your design. If you value clarity, you'll design clearly. If you respect the reader, you'll make the message accessible. If you value the client, you'll make the client's values your own. If you value art, you'll make your work beautiful. If you value innovation, something in every piece will be new. The trick is to value no one of these things more or less than the other.

Burkey Belser, Greenfield/Belser Ltd., Washington, DC

TRADE OUTS CAN WORK FOR EVERYBODY

When we needed a new business piece done, we traded out design for printing and separations. Our arrangement was on a dollar-for-dollar, hour-for-hour basis. This is the best way to do a trade-out. Otherwise, one of the two parties will always feel that the other has gotten the best deal. To avoid any confusion about billed time, we paid raw materials and expenses (paper, film, color Fieries, deliveries) with cash.

*Hal Apple, Hal Apple Design,
San Francisco*

Hal Apple Design worked out a trade-out for separations and printing for its capabilities brochure (top). In exchange, the firm did the design work for Ideal Graphics' brochure (bottom).

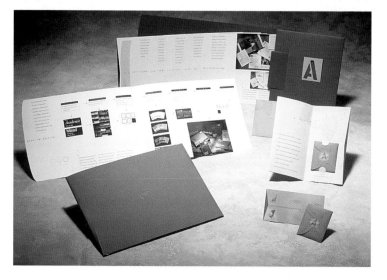

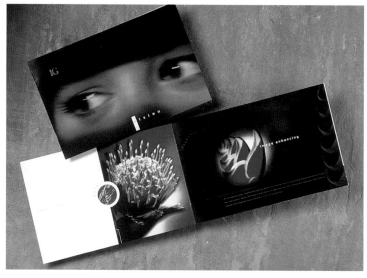

TRYING ON JOBS

If you're not sure what kind of job you want or what kind of design work you want to do, work for a temporary staffing firm for a time. You'll gain valuable experience while you "try on" jobs and companies, discerning what you like and dislike about each. You'll also make good contacts while you are learning.

Rebecca Ranieri, Faith Writing and Design Studio, Norristown, Pennsylvania

DIRTY TRICKS

There is no "right way" to make a publication. The publisher must be ready to use a variety of dirty tricks—whatever it takes to get the pages out the door. The reward for a purist approach to software is frustration. Remember that before there was software, there were scissors and tape. White out, ruby masks and glue sticks are all still sold in art stores and have their uses.

Peter Dyson, Seybold Publications, Media, Pennsylvania

EVERY PROJECT NEEDS A MANAGER

Though it's not easy in a one-person shop, whatever the size of your firm, you should always assign a project manager for every project you take on. This person becomes the focal point for job-related information. This will help avoid confusion and misinformation.

Mel Maffei, Director, Keiler Design Group, Keiler and Co., Farmington, Connecticut; adapted from material published in HOW *magazine, October 1996.*

CUTTING CORNERS

When cutting out comps on a paper cutter, first output the image on 11" × 17" paper. Since it is hard to see exactly where to line up the art to cut along the edge, whack the corners off first. Now lining up the art with the edge of the paper cutter will be much easier.

Shawn Smith Design and David Mill of The Design Mill, Cincinnati, Ohio

If you're trying to cut out comps on a paper cutter, cutting the corners off first makes it easier to line up the art with the edge of the paper cutter.

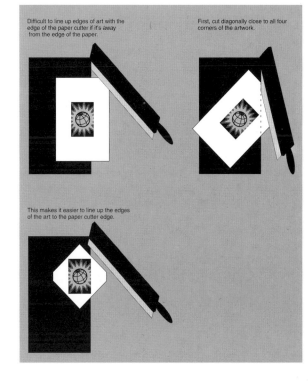

Difficult to line up edges of art with the edge of the paper cutter if it's away from the edge of the paper.

First, cut diagonally close to all four corners of the artwork.

This makes it easier to line up the edges of the art to the paper cutter edge.

CUSTOM PACKING MATERIAL

Want to create custom-colored box packing material? Buy sheets of your favorite colored paper and shred it in your office paper shredder. The more material inside the shredder, the more crinkly the paper will get. But watch those fingers!

Williams & House, Avon, Connecticut

CLEAR GOALS FOR GOOD DESIGN

Designs fail when the designer's goal is unclear or she stops short of the goal, citing this or that excuse (money, time or the client). The only credible excuse is that you weren't up to the task. If you pursue excellence relentlessly, you'll be taking two steps forward for every backward step. If not, every day, you'll take two steps backward for every step forward.

Burkey Belser, Greenfield/Belser Ltd., Washington, DC.

EQUIPMENT INVESTMENT PAYS OFF

We bought a UMAX scanner at a cost of about $800 and recouped the cost within four months. Same goes for our Tektronix color printer ($10,000 plus $1000 warranty). We will pay it off in a year and a half. Now that we have them, we don't know how we ever lived without either of these items. Making the investment in equipment is well worth it.

Hal Apple, Hal Apple Design, San Francisco

TESTING USED HARDWARE

If you're concerned about whether any kind of used drive will work or not, test it—and any other piece of computer hardware—using diagnostic tools like the Ziff-Davis benchmark series. Benchmark software for Macintosh and PC can be downloaded from the Ziff-Davis website (http://www.zif.com:8013/~zdbop).

Joe Farace, photographer/writer, Brighton, Colorado. Joe Farace is contributing editor to ComputerUSER *and* Photo-Electronic Imaging *magazines, technical editor of* Professional Photographer *magazine and author of several books on photography.*

ALWAYS PROOFREAD GRAPHICS

No matter how long you've worked as a designer, make sure you proofread all text used in a design, even if it's in someone else's clip art or a scanned image you've incorporated into a design.

ABSORBING COVER

After the MTV Awards famous fluffy, pink slipper materialed cover, we've got the next installment in wild book covers: false, fake or "faux" chamois. Not only does it make a great cover with truly timely coloring, it also soaks up spills. By adding the perfect finishing touch, Italian silk embroidery, you've not only made a cool cover, you've also made a visually absorbent one.

Gregg Palazzolo, Palazzolo Design Studio, Ada, Michigan

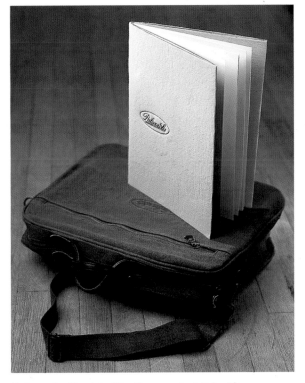

Palazzolo Design Studio created this "faux chamois" cover for a merchandising book.

PERSONAL VISITS

As the principal of your design studio, you're busy most of the time. It is imperative, though, to take some time to meet personally with your clients. It's not necessary to go to every design meeting, but putting in an appearance on occasion will make your clients feel that they are getting personal attention from you.

PERMISSIONS

p. 11-© 1996 Willoughby Design Group. Designer: Michelle Sonderegger. Used by permission.
p. 12-© Erbe Design. Designed by Maureen Erbe Design; published by Rodale Publications. Used by permission.
p. 13-© 1996 Brink Design International, Inc. Design firm: Willoughby Design Group; designers: Ingred Fink, Michelle Sonderegger; copywriter: Mara Friedman; photography: Tim Pott; illustrators: Meg Cundiff, Jeffrey Fulvimari, Ann Willoughby. Used by permission.
p. 15-© 1996 Sayles Graphic Design. Art director, designer, illustrator: John Sayles; designer: Jennifer Elliott; copywriter: Wendy Lyons. Used by permission.
p. 15-© 1996 Turkel, Schwartz & Partners. Design: Turkel, Schwartz & Partners. Used by permission.
.p. 16-© 1996 Turkel, Schwartz & Partners. Design: Turkel, Schwartz & Partners. Used by permission.
p. 17-© 1985 Tharp Did It. Used by permission.
p. 18-© 1996 Hewlett-Packard Company. Design firm: Cotter Visual Communications; designer: Cathy Cotter. Reproduced by permission.
p. 19-© CIGNA Retirement & Investment Services. Design firm: Keiler Design. Used by permission.
p. 19-© 1994 Palazzolo Design Studio. Concept/design/illustration: Gregg Palazzolo; production: Mark Siciliano. Used by permission.
p. 20-© Twin Farms. Design firm: KAISERDICKEN; designers: Craig Dicken, Debra Kaiser. Used by permission.
p. 21-© 1996 Shape, Inc. Design firm: Leslie Evans Design Associates; Design: Leslie Evans, Teresa Otul-Cummings. Used by permission.

p. 22-© 1995 Design Guys Inc. Art director: Steven Sikora; designer: Richard Boynton. Used by permission.
p. 23-© 1996 Lee Company. Design firm: Willoughby Design Group; designers: Ingred Fink, Michelle Sonderegger; photography: Hugh Stewart, Hollis Officer, Tim Pott; illustrators: Meg Cundiff, Cathy Law, Neil Orlowski, Ann Willoughby. Used by permission.
p. 24-© Twin Farms. Design firm: KAISERDICKEN; designers: Craig Dicken, Debra Kaiser. Used by permission.
p. 26-© Design Guys Inc. Art director: Steven Sikora; designer: Richard Boynton; Photographer: Darrell Eager. Used by permission.
p. 27-© *Smithsonian* Magazine. Design firm: Bokuniewicz Design. Designer: Carol Bokuniewicz. Used by permission.
p. 29-© Harley Davidson. Design firm: VSA Partners; Designer: Carlos Segura. Used by permission.
p. 32-© Erbe Design. Designed by Maureen Erbe Design; published by Rodale Books.
p. 37-© 1996 Columbus Society of Communicating Arts and Firehouse 101 art + design. Design firm: Firehouse 101 art + design; art director: Kirk Richard Smith; designers: Kirk Richard Smith, Brad Egnor; digital collage: Keith Novicki, Narcelle Knittel; copy: George Felton. Used by permission.
p. 41-© Kauck Productions. Used by permission.
p. 42-© Baldo Photography. Used by permission.
p. 43-© Erbe Design. Designed by Maureen Erbe Design; published by Rodale Press. Used by permission.
p. 45-© 1996 Cambridge Dry

Goods. Design firm: Leslie Evans Design Associates; designers: Leslie Evans, Teresa Otul-Cummings; logo design: Cheri Bryant. Used by permission.
p. 46-© KAISERDICKEN/Garrett Hotel Group. Design firm: KAISERDICKEN; designers: Craig Dicken, Debra Kaiser. Used by permission.
p. 48-© Erbe Design. Designed by Maureen Erbe Design; published by Rodale Press. Used by permission.
p. 50-© 1995 Timex Corp. Design firm: Leslie Evans Design Associates; designers: Leslie Evans, Cheri Bryant. Used by permission.
p. 53-© Palazzolo Design Studio; Concept/design: Gregg Palazzolo; photography: Labaan Studio; Plazzolor Design Studio. Used by permission.
p. 55-© 1996 Iconomics. Illustration: Margaret Tarleton, Inconomics and Custom Images. Used by permission.
p. 57-© 1996 Dynamic Graphics. Illustrations: Designers Club Service. Used by permission.
p. 58-© Little Men Studio. Designer: Tracey Burroughs. Used by permission.
p. 59-© 1996 KAISERDICKEN and Turtle Holidays. Designers: Craig Dicken and Debra Kaiser. Used by permission.
p. 60-© 1991 [metal] Studio. Designers: Peat Jariya, Scott Head, F. Gerakis. Used by permission.
p. 63-© 1995 Wright Communications Inc. Photography: Diane Padys. Used by permission.
p. 64-© 1996 Buz Design. Creative director: Tricia Rauen; designers: Tricia Rauen, Kelli Kunkel-Day, Rose Hartono. Used by permission.
p. 64-© Engraved Stationery Manufacturers Association.

INDEX BY SUBJECT

INDEX BY SUBJECT (CONT.)

INDEX BY TIP NAME

INDEX BY TIP NAME (CONT.)

INDEX BY TIP NAME (CONT.)

CONTRIBUTORS

Hal Apple Design
1112 Ocean Dr., Suite 203
Manhattan Beach, CA 90266

AV Media
2020 N. Main St., #227
Los Angeles, CA 90031

Baldo Photography
259 Mayer St.
Phoenixville, PA 19460

Richard Banse
Attention Graphic Enterprises
705 General Washington Ave., Suite 201
Norristown, PA 19403

Jacci Howard Bear
JBdesigns
1404 Wooten Dr.
Austin, TX 78757

Burkey Belser
Greenfield/Belser Ltd.
1818 N St., NW
Washington, DC 20036

Kate Binder
Ursa Editorial Design
P.O. Box 356
Rowley, MA 01969-0856

Carol Bokuniewicz Design
73 Spring St., Suite 505
New York, NY 10012

Gilbert Cosme, Jr.
Typography Unlimited Inc.
4005 N. Thirty-first Ave.
Phoenix, AZ 85017

Cathy Cotter
Cotter Visual Communications
101 Eden Rd.
Landenberg, PA 19350-9376

Design Guys
119 N. Fourth St., Suite 400
Minneapolis, MN 55401

Peter Dyson
Seybold Publications

428 E. Baltimore Ave.
Media, PA 19603

Erbe Design
1500 Oakley St.
South Pasadena, CA 91030

Leslie Evans Design Associates
81 W. Commerical St.
Portland, ME 04101

Joe Farace
2392 Deer Trail Creek Dr.
Brighton, CO 80601

Firehouse 101 art+design
492 Armstrong St.
Columbus, OH 43215

Chuck Green
11475 Chicahominy Ranch
Glen Allen, VA 23060

Haywood & Sullivan
1354 Hancock St., Suite 306
Quincy, MA 02169

Stephen Hellerstein
56 W. Twenty-second St.
New York, NY 10010

KAISERDICKEN
149 Cherry St.
Burlington, VT 05401

Jeff Kauck
Kauck Productions
1050 McMillan St.
Cincinnati, OH 45206

Betsy Kopshina
Garage Fonts
P.O. Box 3101
Del Mar, CA 92014

Joe Kotler
Moveable Type
77 Mowat Ave.
Toronto, ON N6K 3E3
Canada

Little Men Studio
17 Highland Ave.
Redding, CT 06896

Mel Maffei
Keiler Design Group
Keiler & Company
304 Main St.
Farmington, CT 06032-2957

MetaDesign
350 Pacifica Ave.
San Francisco, CA 94111

[metal] Studio Inc.
1210 W. Clay, Suite 13
Houston, TX 77019

Palazzolo Design Studio
"The Grange"
6410 Knapp
Ada, MI 49301

Rebecca Ranieri
Faith Writing and Design Studio
1000 Sterigere St.
Norristown, PA 19401

Sayles Graphic Design
308 Eighth St.
Des Moines, IA 50309

John Scott
at.coffee, Inc.
139 Avenue A
New York, NY 10009

Carlos Segura
Segura, Inc.
1110 N. Milwaukee Ave.
Chicago, IL 60622

Shawn Smith Design/David Mill, The Design Mill
19 Garfield Place, Suite 422
Cincinnati, OH 45202

John Stoy
Desktop Prepress Associates
Fairport, NY

Talbot Design Group
310 Westlake Blvd., Suite 220
Westlake Village, CA 91362

Tharp Did It
50 University Ave., Suite 21
Los Gatos, CA 95030

Turkel Schwartz & Partners
2871 Oak Ave.
Miami, FL 33133

Williams & House
296 Country Club Rd.
Avon, CT 06001

Willoughby Design Group
602 Westport Rd.
Kansas City, MO 84111

Nanette Wright
Wright Communications Inc
67 Irving Place
New York, NY 10003

Zender & Associates
2311 Park Ave.
Cincinnati, OH 45206

SOURCE WEBSITES

Adobe Software: http://www.adobe.com
G&R Technologies: http://www.gnr.com
Infomedia: http://www.infomedia.net
The INK Spot: http://members.aol.com/inkspotmag
PrePress Solutions: http://www.prepress.pps.com
Vivid Details: http://www.vividdetails.com
Daniel Will-Harris: http://www.will-harris.com

More Great Books for Knock-Out Graphic Design!

Nana-Fall-River, his Italian grandmother, put one in a special frame on the table next to the photograph of Aunt Clo in her wedding dress.

Once Tommy took a flashlight and a pencil under the covers and drew pictures on his sheets. But when his mom changed the sheets on Monday and found them, she said, "No more drawing on the sheets, Tommy."

His mom and dad were having a new house built, so Tommy drew pictures of what it would look like when it was finished.

When the walls were up, one of the carpenters gave Tommy
a piece of bright blue chalk.

Tommy took the chalk and drew beautiful pictures all over the
unfinished walls.

But, when the painters came, his dad said, "That's it, Tommy.
No more drawing on the walls."

Tommy couldn't wait to go to kindergarten. His brother, Joe, told him there was a real art teacher who came to the school to give ART LESSONS!

"When do we have our art lessons?" Tommy asked the kindergarten teacher.

"Oh, you won't have your art lessons until next year," said Miss Bird. "But, we *are* going to paint pictures tomorrow."

It wasn't much fun.

The paint was awful and the paper got all wrinkly. Miss Bird made the paint by pouring different colored powders into different jars and mixing them with water. The paint didn't stick to the paper very well and it cracked.

If it was windy when Tommy carried his picture home, the
paint blew right off the paper.

"At least you get more than one piece of paper in kindergarten,"
his brother, Joe, said. "When the art teacher comes, you only
get one piece."

Tommy knew that the art teacher came to the school every other Wednesday. He could tell she was an artist because she wore a blue smock over her dress and she always carried a big box of thick colored chalks.

Once, Tommy and Jeannie looked at the drawings that were hung up in the hallway. They were done by the first graders.

"Your pictures are much better," Jeannie told Tommy. "Next year when we have real art lessons, you'll be the best one!"

Tommy could hardly wait. He practiced all summer. Then, on his birthday, which was right after school began, his mom and dad gave him a box of sixty-four Crayola crayons. Regular boxes of crayons had red, orange, yellow, green, blue, violet, brown and black. This box had so many other colors: blue-violet, turquoise, red-orange, pink and even gold, silver and copper.

"Class," said Miss Landers, the first-grade teacher, "next month, the art teacher will come to our room, so on Monday instead of Singing, we will practice using our crayons."

On Monday, Tommy brought his sixty-four crayons to school. Miss Landers was not pleased.

"Everyone must use the same crayons," she said. "SCHOOL CRAYONS!"

School crayons had only the same old eight colors.

As Miss Landers passed them out to the class, she said, "These crayons are school property, so do not break them, peel off the paper, or wear down the points."

"How am I supposed to practice being an artist with SCHOOL CRAYONS?" Tommy asked Jack and Herbie.

"That's enough, Tommy," Miss Landers said. "And I want you to take those birthday crayons home with you and leave them there."

And Joe was right. They only got ONE piece of paper.

Finally, the day of the art lesson came. Tommy could hardly sleep that night.

The next morning, he hid the box of sixty-four crayons under his sweater and went off to school. He was ready!

The classroom door opened and in walked the art teacher. Miss Landers said, "Class, this is Mrs. Bowers, the art teacher. Patty, who is our paper monitor this week, will give out one piece of paper to each of you. And remember, don't ruin it because it is the only piece you'll get. Now, pay attention to Mrs. Bowers."

"Class," Mrs. Bowers began, "because Thanksgiving is not too far away, we will learn to draw a Pilgrim man, a Pilgrim woman and a turkey. Watch carefully and copy me."

Copy? COPY? Tommy knew that *real* artists didn't copy. This was terrible. This was supposed to be a real art lesson. He folded his arms and just sat there.

"Now what's the matter?" Miss Landers asked. Tommy looked past her and spoke right to Mrs. Bowers.

"I'm going to be an artist when I grow up and my cousins told me that real artists don't copy. And besides, Miss Landers won't let me use my own sixty-four Crayola crayons."

"Well, well," Mrs. Bowers said. "What are we going to do?"
She turned to Miss Landers and they whispered together. Miss
Landers nodded.

"Now, Tommy," Mrs. Bowers said. "It wouldn't be fair to let
you do something different from the rest of the class.

"But, I have an idea. If you draw the Pilgrim man and woman and the turkey, and if there's any time left, I'll give you *another* piece of paper and you can do your own picture with your own crayons. Can you do that?"

"I'll try," Tommy said, with a big smile.

And he did.

And he did.

And he still does.